Focus On Composing Photos

The *Focus On* Series

Photography is all about the end result – your photo. The *Focus On* series offers books with essential information so you can get the best photos without spending thousands of hours learning techniques or software skills. Each book focuses on a specific area of knowledge within photography, cutting through the often confusing waffle of photographic jargon to focus solely on showing you what you need to do to capture beautiful and dynamic shots every time you pick up your camera.

Titles in the *Focus On* series:

Focus On Composing Photos

Peter Ensenberger

AMSTERDAM • BOSTON • HEIDELBERG • LONDON • NEW YORK • OXFORD • PARIS
SAN DIEGO • SAN FRANCISCO • SINGAPORE • SYDNEY • TOKYO

Focal Press is an Imprint of Elsevier

Focal Press is an imprint of Elsevier
30 Corporate Drive, Suite 400, Burlington, MA 01803, USA
The Boulevard, Langford Lane, Kidlington, Oxford, OX5 1GB, UK

Notices
Knowledge and best practice in this field are constantly changing. As new research and experience broaden our understanding, changes in research methods, professional practices, or medical treatment may become necessary.

Practitioners and researchers must always rely on their own experience and knowledge in evaluating and using any information, methods, compounds, or experiments described herein. In using such information or methods they should be mindful of their own safety and the safety of others, including parties for whom they have a professional responsibility.

To the fullest extent of the law, neither the Publisher nor the authors, contributors, or editors, assume any liability for any injury and/or damage to persons or property as a matter of products liability, negligence or otherwise, or from any use or operation of any methods, products, instructions, or ideas contained in the material herein.

Library of Congress Cataloging-in-Publication Data
Ensenberger, Peter.
 Focus on composing photos / Peter Ensenberger.
 p. cm.
 Includes index.
 ISBN 978-0-240-81505-3
 1. Composition (Photography) I. Title.
 TR179.E57 2011
 770.1—dc22
 2010048143

British Library Cataloguing-in-Publication Data
A catalogue record for this book is available from the British Library.

ISBN: 978-0-240-81505-3

For information on all Focal Press publications
visit our website at www.elsevierdirect.com

Printed in China

11 12 13 14 15 5 4 3 2 1

Typeset by: diacriTech, Chennai, India

Dedication

To my parents, who probably didn't realize when they gave me my first camera that they also gave me a direction in life.

About the Author

Throughout his career, Peter Ensenberger has crossed photographic boundaries to explore different styles and diverse subjects. After studying fine art photography in college, he went on to win awards as a staff photojournalist for several newspapers. More recently, he served 25 years as director of photography for Arizona Highways, the award-winning nature and travel magazine. His responsibilities for the magazine covered a wide range of roles—photographer, photo editor, writer, and project manager. Peter left Arizona Highways in 2009 to devote full time to his own photography business. Currently, he resides in Tempe, Arizona, where he is a freelance photographer for Black Star, an international photo agency based in New York. Corporate and editorial assignments make up the bulk of his work, with an emphasis on travel and lifestyle. In addition, he leads group and individual photo workshops to Arizona's most beautiful and remote locations.

Acknowledgments

I wish to thank Valerie Geary, Stacey Walker, Graham Smith, Laura Aberle, Kara Race-Moore, and all at Focal Press for their patience and guidance in sharpening both thought and presentation. For shedding light along the way, much appreciation goes out to Derek Von Briesen and Scott Condray. And for her loving encouragement, support, and advice in bringing this book into clearer focus, I would like to give special thanks to my wife, Kim.

Peter Ensenberger

Introduction

PHOTOGRAPHY IS A universal language capable of communicating to a wide audience. But photography also is a very personal affair. No two of us approach it exactly the same way. You bring to bear your own personal experiences and influences every time you push the camera's shutter-release button. Each image captures a moment in time seen through your eyes, processed by your way of seeing the world.

That's the appeal of photography as a form of self-expression. It allows each of us to artfully interpret the world around us or create our own alternative reality. For many, it's our principal creative outlet, producing images that can be easily shared with others.

With the advent of digital technology, photography has grown into one of the most popular hobbies in the world today. It's the most accessible of all art forms. As a fun and affordable pastime, photography truly is the art of the masses.

Those committed to improving their skills and techniques may enjoy lifelong partnerships with their cameras, producing photographs to be proud of. If you're persistent and willing to push yourself to achieve loftier goals, your images will begin to reveal a personal style all your own.

A good first step in refining your style is learning the fundamentals of composition that have stood the test of time. It's worth noting that many of the world's great photographers had no formal art training. They developed their visual sensibilities through observation and perception. Aspiring photographers should follow their lead.

Defining the artistry of composition, photography pioneer Edward Weston cut straight to the heart of the matter with an economy of words. "Composition," he said, "is the strongest way of seeing."

All around us, the elements of composition—objects, lines, shapes, colors, and shadows— coalesce in apparent disarray. By raising your awareness of the orderly way these elements fit together, you'll realize the strongest way of seeing. Learning the basics of good composition helps you recognize the essential components and design artistic arrangements from the chaos. You'll produce better photographs that combine balance, simplicity, and style.

For anyone whose design skills are not intuitive, practicing the fundamentals of good composition will lead to informed decisions. It's helpful to understand the reasons behind the so-called rules of composition. Whether you're a beginning student of photography or someone who has been working at it for a while, improving your compositional skills will help you create photographs that are visually pleasing and stand up to critical scrutiny. Knowing the basics allows you to quickly recognize the potential in any

scene, design an aesthetically pleasing composition, and then capture it the best way possible. With a little practice and repetition, applying the rules of composition will become second nature to you.

First, the rules of composition are meant to create balance and visual harmony in any work of art, be it a photograph, painting, or sculpture. Better photographs can result from knowing the rules of composition, and it's okay to bend or even break the rules with good reason. Sometimes disregarding the rules introduces dynamic tension to good effect. But it's important to know and practice the basics before deviating from them.

Second, the purpose of good composition is to orchestrate the viewer's eye movement as it explores the image. Critical placement of compositional elements effectively leads the eye into and through the scene, containing it within the boundaries of the frame and eventually leading the viewer's eye to the focal point—the composition's visual payoff. The longer viewers are engaged by the composition, the more of the image they will see.

Another important basic step in every photographer's education is learning to work with light. Composition and light go hand in hand. The prominence and placement of highlights and shadows become important compositional elements when properly incorporated in your photographs. Using the pre-vailing light to its best advantage in any situation will have an immediate positive impact on your images. Making sure that the direction and quality of the light favors your subject is sometimes more important than the subject itself. Conversely, a poorly lit subject can ruin the success of even the best composition.

Much like the human brain's left (analytical) and right (intuitive) cerebral hemispheres, photo-graphy has opposable sides—the technical and the creative. The technical side is restricted by absolutes. For each desired result, there is a required action. If you need more depth of field, adjust the aperture. If you want a lighter exposure, change the shutter speed. Understanding photography's technical process is straightforward and can be easily learned.

Rules governing the creative side, on the other hand, are open to interpretation. They serve more as guidelines than doctrine, providing a framework within which we can evaluate the effectiveness of visual design. There are no absolutes that, when faithfully executed, will guarantee a well-designed photograph, and even a perfectly composed image can be deadly dull if the story is boring. Your creativity is the X-factor in elevating your photographs above the ho-hum.

Photography's greatest assets are its abilities to visually commu-nicate ideas and to bring a height-ened awareness of beauty to our daily lives. When ideas and beauty combine successfully with sound compositional techniques, a photograph can achieve the level of art.

Getting started

You'll need a few essential tools to get started. And with the wide array of photographic equipment available, you've got some important choices to make. Those choices should take into account your current

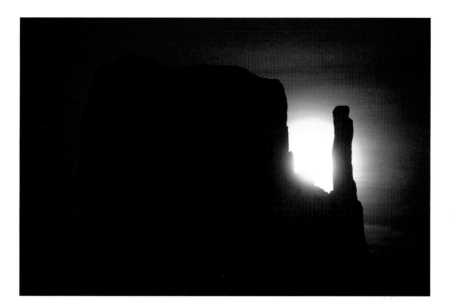

Critical placement of compositional elements and using the prevailing light to its best advantage will have an immediate positive impact on any image.

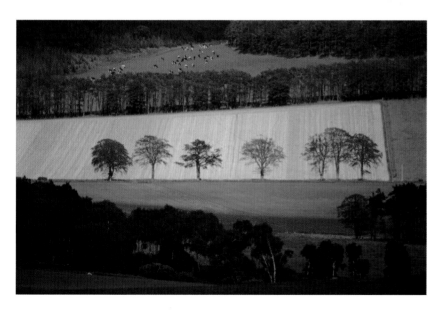

A zoom lens allows you to easily select the best perspective for any subject. Good optical quality is vital to capturing sharp images rendered with accurate color and contrast.

skill level and the level to which you aspire. Knowing this helps you select equipment you'll be comfortable using now, but it also allows room for growth. Your equipment's sophistication level should increase right along with your improved technique.

Photography magazines and online forums are saturated with facts and opinions about the latest-and-greatest gear on the market, and user reviews can be invaluable in making informed choices on equipment you are considering for purchase. But buying the newest and best camera will not necessarily result in better images. In short, cameras don't make good photographs; photographers make good photographs.

You already possess the most important piece of "equipment" you'll need to become a better photographer—it's between your ears. Studies estimate that 80 percent of the human brain is wired to process visual data. By honing your visual-awareness skills, you can train yourself to recognize the potential in every photographic situation. And you don't even have to download the latest firmware updates!

Of course, the camera is the primary tool you'll be using. It makes sense to start with a fairly basic model offering intuitive operation and one- or two-step controls with user-friendly menu functions. Advanced equipment with complicated features can become an impediment to the image-making process, so don't feel like you need to spend a lot of money on bells and whistles. The easier the thought process for your camera's operation, the more likely you are to be successful at it. And the more success you have, the more you'll enjoy your photographic experiences.

In the beginning, set aside time to use your camera every day, if possible. Read and reread the user's manual until you are able to operate all the camera's functions without referencing the instructions. There are no shortcuts to learning your camera's operation. Hands-on experience is the best teacher. With repetition comes familiarity with your camera's functions, allowing the image-making process to become more fluid. Ultimately, the goal is to make the camera an extension of you, operating almost automatically in

your hands. This frees your mind of technical concerns so you can concentrate on the artistic side of the process.

The next tool you'll need in your equipment bag is a lens. If you're currently using a point-and-shoot camera with built-in lens, the choice has already been made for you. However, most digital single-lens-reflex (DSLR) cameras allow for interchangeable lenses. Zoom lenses offer the most versatility, including features such as auto focus, "fast" aperture, close-focus capability, and broad focal-length range. A zoom lens with coverage ranging from wide angle to telephoto provides the most options in one package. Zooms also are budget friendly, with one lens taking the place of several fixed-focal-length lenses.

Only the best optical glass should come between you and your subjects, so don't skimp on quality when purchasing a lens. Good optical quality is vital to capturing sharp images rendered with accurate color and contrast. Optics can vary widely among lenses and brand names, so a little research is

well worth the time invested in selecting the proper lens for your needs. Buying the best lens you can afford will help ensure good image resolution.

Another tool essential to image sharpness is a sturdy tripod. Mounting the camera on a solid base prevents camera movement during exposure and helps maintain sharp edges on your subjects. It's difficult for even the steadiest of hands to hold the camera perfectly still at shutter speeds of 1/60 of a second or slower. Photographers who pay extra for the sharpest lenses and then handhold their cameras may negate the advantages of buying expensive glass.

Tripods, like lenses, call for quality. Beware of cheap, flimsy tripods with weak leg joints. They don't provide proper stability or stand up to the rigors of use, so you'll be replacing it every time it breaks down. Paying more for a sturdy, carbon-fiber tripod with a solid ball head and a quick-release mechanism is a wise investment that should last you the rest of your life. If you've spent your hard-earned cash on a good camera and lens, you don't want to risk mounting them on a shaky tripod.

Using a tripod also has the advantage of slowing down the image-making process, which reduces mistakes and wasted exposures. Mounting the camera allows time for you to closely scrutinize a composition and tweak adjustments to framing. It's difficult to steady the camera in your hands long enough to identify problems and make nuanced corrections. By slowing down, you're more apt to notice subtle distractions around the edges and corners of the frame, where attention to detail can mean the difference between a good composition and a mediocre one. Other tripod benefits include precise leveling of your camera and alignment of parallel lines in your compositions.

Camera, lens, and tripod—by utilizing these three tools as your basic setup and becoming proficient in their operation, you'll be ready to delve into the creative side of photography. In this book, I have attempted to explain the artistic approach in a straightforward manner. Now it's time to play with the spatial relationships within your camera's viewfinder.

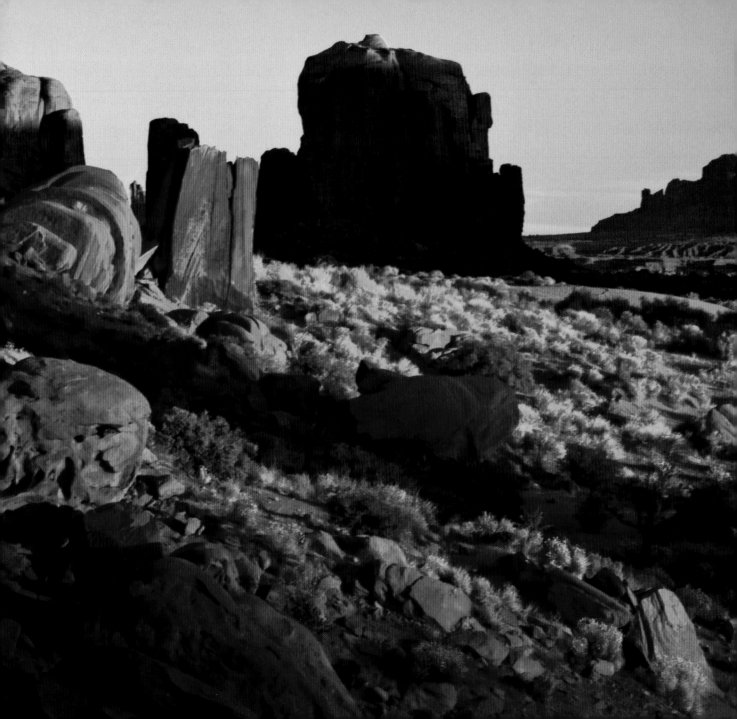

Contents

Contents

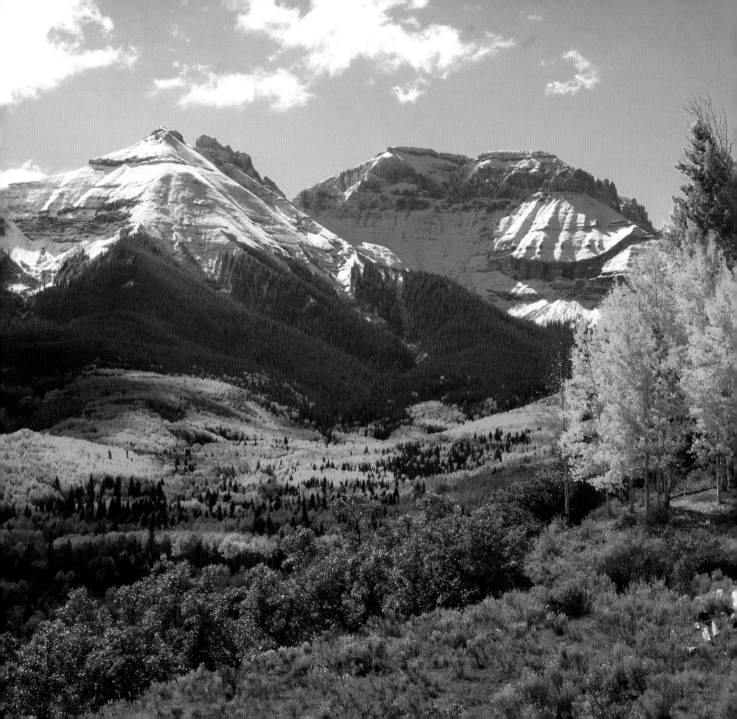

Chapter 1: A Strong Focal Point

What is my subject?

OUR DIVERSE PLANET offers a vast array of subjects to arouse our imaginations. This fascination with the world entices us to explore its creative possibilities through photography, focusing on such themes as landscapes, nature, abstracts, and people. Although the approach to photographing each of these subjects calls for a different strategy, they all require sound techniques to become successful compositions. By learning how, when, and why to apply a few artistic standards, you'll be able to capture any subject at its best.

Composing an aesthetically pleasing scene around your subject requires an assessment of the subject and its surroundings; light direction and shadows; viewpoint and perspective.

Normally, the subject is the impetus for a photograph. Start by asking yourself this simple question: What is my subject? It may be majestic snowcapped mountains dominating the landscape, a hummingbird hovering at a purple flower, or your child blowing out the candles at a birthday celebration. The subject is the central figure around which a photograph's story revolves. Its striking qualities attract our attention and draw us in for a closer look. But while it may be the subject that first attracts people to stop and look at a photograph, it is the artistry of composition that holds their attention.

Composing an aesthetically pleasing scene around your subject requires a quick but studied assessment of several factors: subject and surroundings, light direction and shadows, viewpoint and perspective. Every situation presents a unique set of variables, and it's up to the photographer to make sense of it all by combining the elements as artfully as possible so that the resulting photograph communicates

a narrative or informs the viewer about the subject.

The importance of a subject's strong presence in any photograph cannot be overstated. Objects offering interesting textures, colors, shapes, and lines often make the best subjects. The more interesting your subject, the more obviously it becomes the focal point of your composition, so play up those interesting qualities. Boldly featuring the subject in a composition leaves no doubt about the story being told.

Compositional elements may include colors, patterns, textures, leading lines, highlights and shadows, main and subordinate subjects, and even blank or neutral space. These are the building blocks of visual design. The way in which they are arranged within the composition should work together to deliver the viewer's eye to the subject, the composition's visual payoff.

In basic terms, composing a photograph is an editing process—deciding which elements to include and which ones to leave out. Look through the camera's viewfinder. This is the decisive moment. You must account for all of the physical components laid out before you and make critical decisions about them based on the story you're attempting to tell about your subject. The final image's success or failure depends on the considered choices you make.

Start by asking yourself this simple question: What is my subject?

Composing an aesthetically pleasing scene around your subject requires a quick assessment of these factors:
- Subject and surroundings
- Light direction and shadows
- Viewpoint and perspective

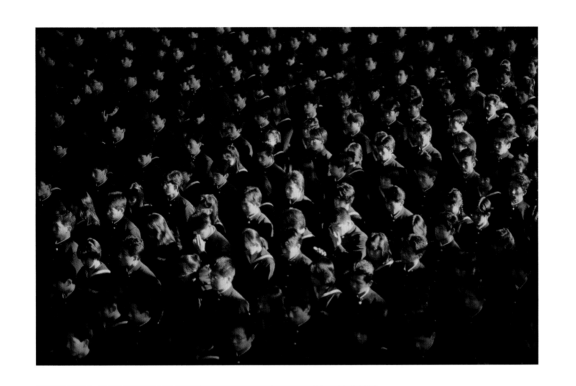

COMPOSITIONAL ELEMENTS

Compositional elements are the building blocks of visual design. They include the following:

- Colors
- Patterns
- Textures
- Leading lines
- Highlights and shadows
- Main and subordinate subjects
- Blank or neutral space

Boldly featuring the subject in your composition leaves no doubt about the story you're telling.

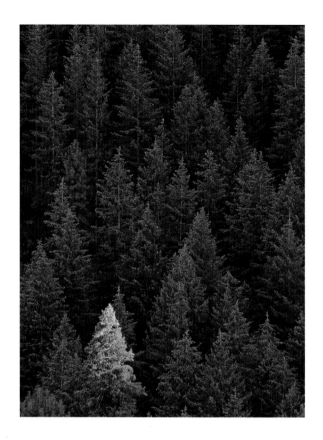

As the brightest spot in the composition, the lone sunlit tree becomes the focal point by default.

Main subject versus focal point

Fortunately, centuries of artistic expression have given us a few useful rules for good composition to help with those decisions. One of the most important compositional rules to know and understand is this: The viewer's eye always goes to the brightest part of a scene.

It has to do with genetic information encoded in our DNA that's been passed down through millennia of human evolution. Like moths to a flame, our eyes are drawn to anything shiny, white, sparkly, or bright, so be certain that the brightest parts of your compositions are worthy of the attention they will receive.

In the grand scheme of a photograph, the brightest object becomes the focal point by default. Watch out for distracting bright spots around your subject. Even a tiny speck of sunlight peeking through tree leaves that goes unnoticed in the viewfinder can have a negative impact on the final image. This results in the unintended consequences

of pulling attention away from the main subject and creating a visual conflict in the composition.

A vital distinction must be made here about the difference between a composition's main subject and its focal point. The main subject is the primary element around which the photograph's narrative is arranged. The focal point is the precise spot in the composition that draws the attention of the viewer's eye. The basic objective of good composition is to make sure that your subject and your focal point are one and the same. That way, there is no conflict over where the viewer's eye should come to rest.

It's usually best to have one main subject as the focal point because a photograph generally can tell only one story successfully. The main subject can be one object or several, and you may decide to include a secondary subject. But make sure nothing distracts from the main subject. Lacking a strong center of interest forces the viewer to search for something to observe, eyes seeking a resting place.

> One of the most important compositional rules to know and understand is this: The viewer's eye always goes to the brightest part of a scene.

The main subject is the primary compositional element around which the photograph's narrative is arranged. The focal point is the precise spot that draws the viewer's attention. The objective of good composition is to make sure that your subject and your focal point are one and the same.

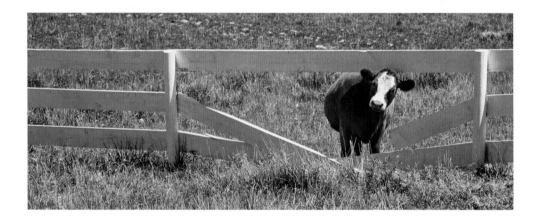

This composition leaves no doubt that the cow is the focal point. The scene's simple design and subordinate elements all work in support of the main subject.

Harmony and emphasis

Your subject should look perfectly at home within the frame. As a rule, the subject's surroundings and other subordinate elements that you choose to include should be in harmony with the story or theme of your photograph. Harmony refers to the inner sense of order among all elements in a unified composition so that each contributes to the overall story being communicated. Including elements that are not harmonious leads to chaos that can muddle your message. The goal is to engage viewers with precise control over the sequence in which visual events in the frame are observed. Anything that interrupts this sequence confuses the story, which can lead to premature termination of the viewer's experience—the viewer looks away.

The subject of a photograph is more than a mere component of the greater whole. It is the star attraction and should be treated to a place of prominence in the composition. There are several ways to give your subject sufficient status so that all other elements are subordinate. Size, color, and placement within the frame play important roles in differentiating between the subject and the supporting elements as they compete for dominance and subordination in the scene.

The most direct approach for conferring emphasis on your subject is through size and proportion within the frame. An obvious association is that larger objects dominate smaller ones. Positioning your camera closest to the intended subject usually accomplishes this effect. But even if your main subject is small, you can give it prominence as the focal point by composing empty space around it. Lens choice and perspective also have a decided effect on the subject's proportion to other elements in your scene, and we'll delve deeper into those issues in Chapter 3.

Color itself can set a subject apart from the rest of your compositional elements. Warm-colored objects dominate cool-colored ones, and saturated primary colors tend to predominate paler tones. Complementary colors such as yellow and blue (warm versus cool) work well to establish a composition's hierarchy, whereas harmonious colors such as blue, green, and purple tend to keep compositional elements on equal footing. Some colors are associated with specific moods or elicit emotional responses. Others appeal to our senses in a purely abstract way. Composing an effective color photograph is more involved than the basic considerations of shape, line, and texture that apply mostly to black-and-white photography. The interplay of color, tone, and hue and their effects on composition get a fuller discussion in Chapter 2.

A third way of bringing emphasis to your subject is through the placement and positioning of elements within the frame. A centrally located object draws more attention than those around the periphery. However, the center is not the best place to position a dominant focal point. It's often more effective to place it to the left or right of center in an asymmetrical balance of elements. This is part of the theory behind the infamous "rule of thirds" and, as we'll see in Chapter 4, deserves heavy consideration anytime you're composing a scene.

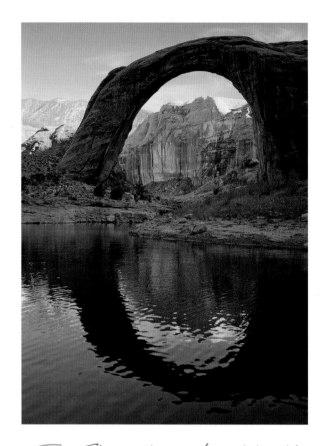

The prominence of Rainbow Bridge, as well as the repeating reflection, brings added emphasis to the natural arch as the main subject, even though it's not the brightest object in the scene.

The main subject is the star attraction and should be treated to a place of prominence. There are three easy ways to ensure your subject's importance within the context of the visual narrative:

- Large size and proportion
- Warm or primary color
- Placement within the frame

Harmony and flow

The subject should look perfectly at home within its setting. The environment and all subordinate elements should be in harmony with the theme of your photograph. Harmony refers to the sense of order among compositional elements so that each contributes to the message. Including elements that are not harmonious muddles that message. The goal is to engage viewers with precise control over the sequence in which the viewer's eye explores the image. Anything that interrupts this flow could lose your audience—the viewer looks away.

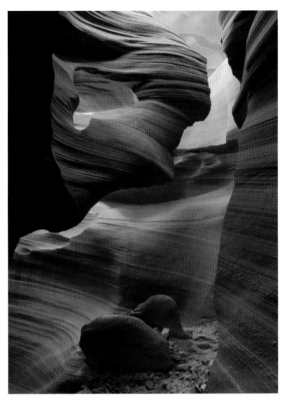

Keep it simple

When it comes to visual design, a key ingredient is simplicity. Its importance in photographic composition cannot be overstated. Simplicity is an easy concept to grasp but often a difficult result to attain. Influential photographer Pete Turner summed up the dilemma this way: "Ultimately, simplicity is the goal in every art,

and achieving simplicity is one of the hardest things to do. Yet it's easily the most essential."

As we've seen, a single photograph can usually convey only one story at a time. The best way to present a clear message is to keep the composition as clean as possible. The fewer elements you have to deal with, the easier it is to feature your subject,

orchestrate viewer eye movement, and inform the viewer. When presented with too many compositional elements, consider splitting them into two or three simpler photographs rather than trying to pack everything into one complex image. The decisions you make here will impact whether your visual message is properly communicated to viewers. Chances are, you won't always be present

to explain it to them, so your composition will have to do the talking for you. To keep your visual message clear, strive for simplicity. If your viewers must work too hard to figure out the story, they will become bored and move on.

Although it is often preferable to keep every element in sharp focus from foreground to infinity, as with landscape subjects, sometimes a shallow depth of field is beneficial in achieving simplicity. A telephoto lens and a large aperture setting can effectively shorten depth of field, isolating the subject from a busy background by defocusing objectionable background clutter. In the right situations, it may even create soft pools of complementary color behind the subject.

A common *faux pas* in photography is setting up the camera too far away from the subject. Twentieth-century photojournalist Robert Capa, famous for his

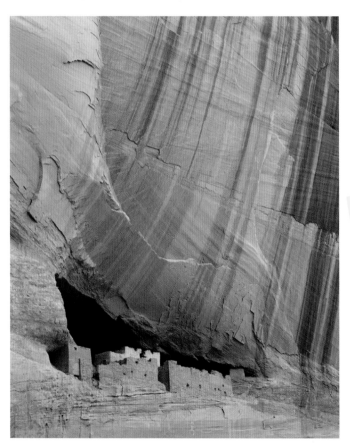

Moving closer to the subject simplifies the composition and focuses more attention on the small cliff dwelling.

Moving closer to the subject simplifies your composition, isolates and emphasizes your subject, and eliminates distractions and other superfluous elements.

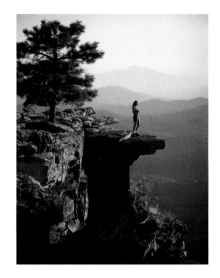

documentation of five wars, may have said it best: "If your pictures aren't good enough, you're not close enough." Tragically, Capa died following his own advice when he tripped a land mine trying to get closer to the action. But for the rest of us working under safer conditions, moving closer to the subject can lead to vast improvements in a composition. Don't be shy. The closer you get to your subject, the more importance you bestow upon it.

Moving in closer to your subjects also has the effect of reducing the amount of space you have to work with, essentially simplifying the composition. Whether you physically move the camera closer or zoom in optically, getting closer allows you to pare the composition down to its essential components. It removes visual distractions from the edges of the frame, eliminates superfluous elements, and defocuses the background.

Subject and Simplicity

Even though this photograph's main subject, the human figure, is small, the photographer has given it prominence as the focal point of the composition by allowing plenty of neutral space around it. The primary color of her shirt also gives added emphasis. The tree, though larger than the main subject, has been given subordinate status as a secondary subject because the photographer has positioned it on the periphery of the composition and created a buffer of space between it and the main subject. Including only a few compositional elements keeps the scene simple and the message clear.

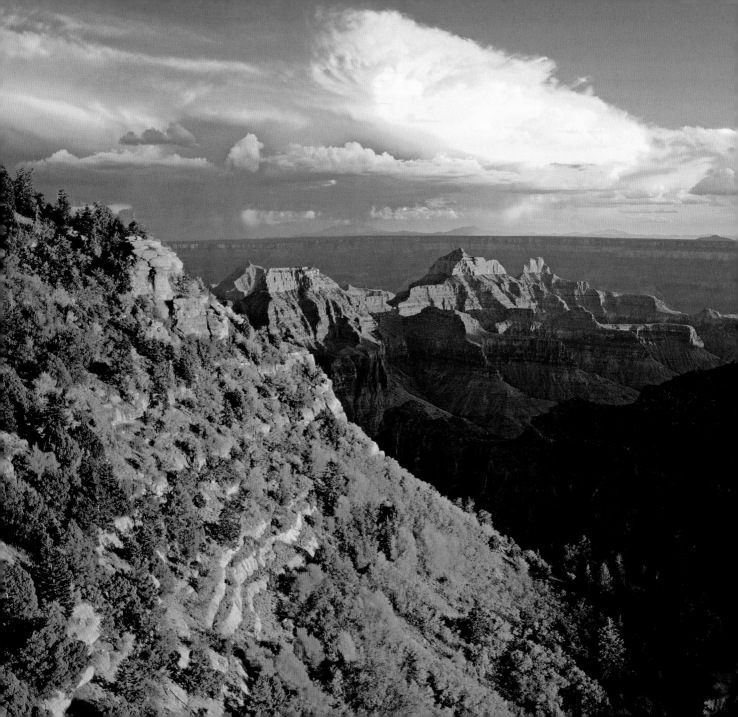

Chapter 2: Light, Shadow, and Color

Sharpen your awareness

PHOTOGRAPHERS ARE OBSERVERS. Their ability to analyze light conditions is one profound difference that sets them apart from snap shooters. By definition, a snapshot is a hurried shot fired with little aim or preparation. Snap shooters go willy-nilly into every photo situation without taking time to consider the all-important interplay of light and subject. They point the camera in the general direction of a subject, click off a shot, and move on. Unfortunately, their lack of attention to detail shows in the results. Their pictures usually feature confusing composition and harsh or indifferent light. It's pure luck if one of their snapshots happens to turn out well.

Of course, everyone can use a little bit of luck, but it's best not to rely on it for success. As the saying goes, "Luck favors the well-prepared." That preparation includes sharpening your awareness of light and how it interacts with the subject. Being acutely sentient of your surroundings at all times is part of the photographer's job description.

Because not much can be done to control the light outdoors, photographers strive to always put themselves in situations favorable to good lighting conditions. Usually, that means being on location during sunrise and sunset hours to take advantage of the low, warm tones of first and last light. It can be the most rewarding time of day. Photographers call it "prime" or "sweet" light, when the sun is only a few degrees above the horizon. At these times of the day, sunlight carries with it a lot of extra color that enhances everything it touches.

During morning's first minutes after sunrise and evening's last minutes before sunset, the sun's light passes through more of the earth's atmosphere than at any other time of day. The combination of airborne dust, pollution, and moisture acts like a giant diffuser to soften the sun's light, filtering it toward the red or warm end of the spectrum. Because daytime activities and winds stir up a lot of extra particulates in the atmosphere, and they tend to settle during the calm of nighttime, sunset hues are usually warmer and more diffuse than the purer light at sunrise.

Long shadows and reddish light make sunrise and sunset the best times to photograph dramatic landscape subjects, such as the Grand Canyon.

Morning and evening also provide the strongest directional light of the day, creating long shadows that add drama to a scene and make subjects appear more three-dimensional. Low cross light raking over the landscape at right angles accentuates the form and texture of everything in its path. With only a few minutes of prime light in which to work, you must move quickly to capture outdoor subjects while light conditions are optimal.

Light creates highlights and shadows of varying intensity all around us, and in a photograph they can become powerful controllers over the sequence of a viewer's eye movement. We've already seen how bright spots can affect the flow of a composition by attracting attention. Shadows have the opposite effect, allowing the viewer's eye to skip easily past darker areas of a composition where texture and detail are muted. They serve as an important ingredient in the recipe for control of eye movement. Highlights and shadows must be accounted for in the same way as any three-dimensional object in your composition.

Highlights and bright spots attract attention; shadows and dark areas deflect attention.

Shadows create a sense of drama in a photograph.

Assignment: Awareness

You can train yourself to become a keen observer by developing your consciousness of light and shadow. A good exercise to hone your awareness is studying the light in images you see in magazines, books, and galleries. Consider the light's source, direction, and intensity, and pay particular attention to the way photographers use the light's best qualities to favor their subjects. When touring art exhibits, make it a point to look specifically at the quality of light that artists create in their paintings. As you go about your daily routine, take time to observe the different ways light and shadows play on common, everyday objects. Awareness and recognition of the quality of light around you should become second nature. Once it clicks in, you probably won't be able to turn it off.

As discussed earlier, the photographic sequence normally begins by finding a subject, then watching and waiting for the light to reach peak enhancement before tripping the shutter. But photography doesn't always have to be subject driven. Being cognizant of the way good light quality can flatter any subject is the best way to develop your awareness. The beauty of light can transform even the most ordinary objects, so sometimes it's good practice to turn the equation around and let the light be your motivation. If dramatic light presents itself, seek out subjects that are elevated in stature by the flattering light conditions. It's a great way to test your newly heightened awareness of light. When the prevailing light—not the subject—becomes your first consideration for making a photograph, you've got it figured out.

1.00 PM 4.00 PM Sunset

Best light of the day

Working in the light that occurs early in the morning and late in the afternoon will have immediate positive impact on your photography. Rising early for the best light of the day costs you only a bit of sleep, but the benefits are worth the price. Sunlight is softened and warmed as it passes through long, dense swaths of the earth's atmosphere. Low angles of the sun's rays at sunrise and sunset also provide the strongest directional light of the day. Position your camera to take full advantage of the long rays raking across the landscape at right angles. Directional light accentuates a subject's form and texture by casting highlights on one side and shadows on the other for a three-dimensional effect. But prime light is fleeting, so be prepared to make compositional decisions quickly. This is a time when familiarity with your equipment pays dividends.

Make the light work for you

Once you've determined the main subject as the starting point for a photograph, your next consideration is how to skillfully work the prevailing light conditions into your composition. Light is an integral part of the composition—as important as the subject itself—so make it a priority in your assessment of the scene. Start with a close inspection of your subject with the naked eye. Pay particular attention to how the prevailing light conditions play upon it.

Does the light complement the subject, or does it interfere with your ability to show off the subject's best attributes? To give any subject the prominence it deserves and make it the focal point of the composition, the prevailing light should always favor your subject.

As implied earlier, the prime light of sunrise and sunset is often the best light of the day in terms of quality, color, and direction. But there are no absolutes regarding light. Optimal light varies with each situation and subject matter, and it's up to the photographer to decide when the most appropriate light is striking the subject. You need not become an expert in the physics of light, but awareness is key in anticipating the optimal moment to trip the shutter.

Your subject might be bathed in golden sunset light with dramatic highlights and shadows accentuating its form and texture; if overcast conditions prevail, soft, flat light will be evenly spread over the subject's surface with no apparent shadows; or it may be backlit, appearing as a shadowy silhouette. The lighting possibilities are endless, and you must decide which lighting best portrays your subject. If possible, take a 360-degree walk around the subject, viewing it from all angles. This helps you find the precise spot that makes best use of the prevailing light on your subject, and it's the best camera position from which to start building your composition.

The way your subject is illuminated plays a huge role in the narrative presented in your photographs. Light sets a tone and creates a mood. If your aim is to inform the viewer about your subject, strong directional light that reveals all its detail is best suited to the task. If the story is one of mystery, light and shadow effects that obscure the subject will leave more to the imagination. Light holds the power to elevate a subject, express a mood, and affect the way people respond to your photographs, so be certain it is consistent with the narrative.

Of course, nature does not always present beautiful prime light. Clouds and weather can get in the way. Overcast, hazy, or foggy conditions will soften and diffuse the light, robbing your surroundings of shadows. But good photographers adapt. On dull, overcast days, point your camera down toward intimate landscapes or close-up subjects that benefit from soft, even light. When a storm moves in, turn the camera skyward to take advantage of the dramatic play of light unfolding above the landscape.

We've looked at the positive effects of working in prime light. Now, let's examine the creative use of other types of light.

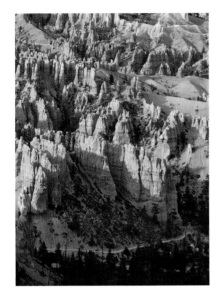

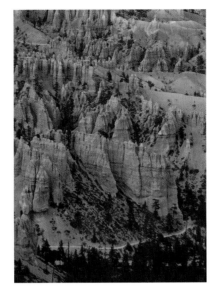

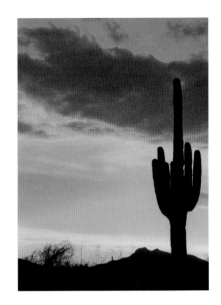

Light is just as important as your subject, so give it priority in building your composition.

Before setting up the camera, view your subject from all angles.

Beware of sunlight striking the front of your lens. Use a lens hood or your hand's shadow to shade the front element from the sun's direct rays.

Backlight

Budding photographers learn from the start that front-lighting their subjects usually rewards them with safe and satisfactory exposures. The problem is, it's not very creative, and it tends to flatten the subject, voiding any textural interest. Safe and satisfactory is just not good enough—we want the "wow" factor. One way of defeating the hardness of direct sunlight is to backlight the subject.

Light coming from behind the subject can help to create more interesting visual and graphic effects. Backlighting produces strong separation between subject and background by creating a rim of light or "halo" effect around the subject. Use this type of lighting to emphasize the shapes of subjects. Backlight also is best for capturing the translucent quality of flower petals and foliage, such as colorful autumn leaves. And backlight can be used to silhouette a subject, producing images with strong graphic qualities.

When utilizing backlight, beware of sunlight striking the front of the lens. Use a lens hood or the shadow from your hand to shield the front element of the lens from direct rays of the sun. This prevents unwanted haze and lens flare in the photograph.

Because backlighting can trick the camera light meter's exposure settings, it's a good idea to bracket exposures to ensure properly exposed highlights and shadows. Exposure compensation settings also allow you to override the meter and lighten or darken the scene to suit your vision. And another way to achieve just the right amount of shadow detail on a backlit subject calls for the use of flash or a small solar reflector focusing light on the front of it. If a silhouette effect is desirable, no shadow detail is necessary.

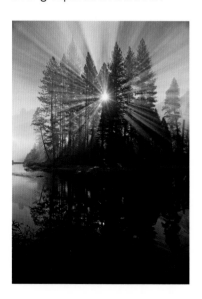

Backlight and unusual atmospheric conditions turn an ordinary grouping of trees into a dramatic subject.

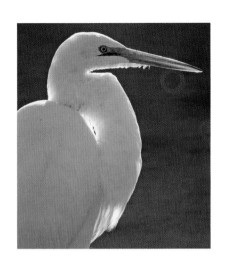

A halo of warm backlight accentuates the shape and textures of an egret at sunset.

Bracketing exposures (shooting the same scene at various exposure settings) ensures a properly exposed image when working in tricky lighting conditions, such as backlight and storm light, where contrast levels are high.

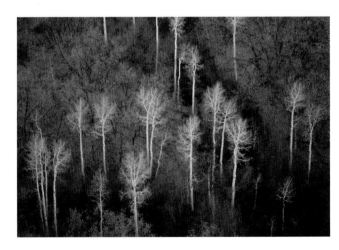

Soft, nondirectional light leaves this scene of bare aspen trees completely devoid of shadows.

Soft light

Overcast conditions provide soft, diffused light that spreads evenly over the landscape with no discernable direction. Without strong highlights and shadows, it's nearly impossible to construct a dramatic composition. An overcast sky doesn't necessarily mean that you have to put away your camera for the day, but it does force you to adjust your photographic strategy. These are good times to focus attention on smaller subjects or work on close-up or macro techniques.

Soft light is usually nondirectional, making it acceptable for portraits and other situations where "contrasty" light is not aesthetically pleasing or complementary to the subject. Photographing under soft lighting conditions often enriches subtle hues and emboldens primary colors.

But beware of heavy overcast or dark clouds where minimal light will mute the colors and soften the details of your subjects. Under these circumstances, it may be better to wait it out, giving the clouds a chance to clear.

Overcast lighting conditions often force photographers to focus on smaller subjects and intimate landscapes. They can be rewarded with bold colors in rich tones.

Storm light

The lighting condition that excites many nature and outdoor photographers the most is storm light. Photographers are weather watchers who keep up with the latest forecasts and storm reports. They know that weather creates unique moods and dramatic conditions. They relish the buildup and break of a storm and scoff at the hazards to capture awe-inspiring images of weather's spectacular fury and theatrical light. For them, there is no such thing as bad weather.

Here are a few items to keep in your camera bag in case of stormy weather:

- A large plastic trash bag for covering the camera
- An absorbent towel for drying off hands and equipment
- A compact collapsible umbrella to keep rain off you and your equipment

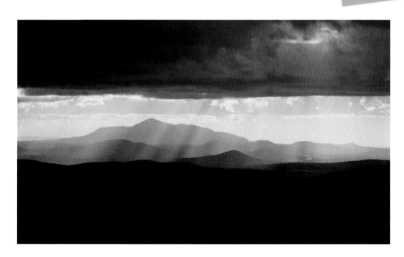

The clash of sunlight and storm clouds combine to create dramatic atmospheric conditions.

Storm warning!

One strong word of warning about working in stormy conditions, and this cannot be overemphasized: Lightning is unpredictable and must be treated with the utmost respect. Always seek safe shelter immediately when lightning storms approach. A ramada or other roofed enclosure won't provide safe haven from lightning if it's not properly grounded. It's far better to miss a great shot than to suffer the tragic effects of a lightning strike.

When the leading and trailing edges of a brooding storm clash with the sun, the light display can be magical. Most modern photographic equipment can tolerate brief exposure to moisture, but be sure to pack a towel, a large plastic bag, and a collapsible umbrella in your photo bag in case you and your camera gear need protection from a determined downpour. Once the storm has arrived and weather is socked in with diminished light and rainy or snowy conditions, photography can

be futile. Most photographers pack up and stay warm and dry until the storm breaks and the trailing edge arrives, when it's time again to turn their eyes skyward.

Exposures can be tricky when bright shafts of sunlight pierce through dark storm clouds. The contrast level between highlights and shadows makes it difficult to get a pleasing exposure. In these cases, you can accurately capture the brightest highlights by simply underexposing

the scene by two stops to get saturated color and rich black clouds. Again, bracketing your exposures ensures that you will get the best saturation level and gives you more options when editing later.

Midday light

Unfortunately, we can't always be in the right place at the right time to capture the prime light. Travel itineraries and other factors occasionally force us to work in less

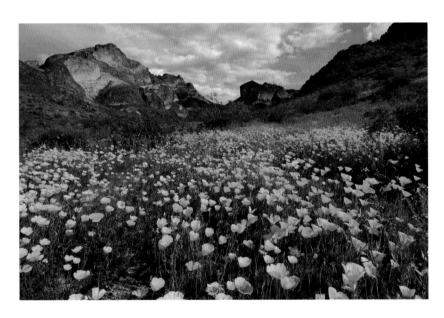

The unflattering light of midday must be accommodated at times. Poppy blooms open their petals only in strong sunlight, forcing photographers to work in less-than-optimal light conditions.

than optimal lighting conditions. Typically, the high, overhead sun of midday is the worst light of the day. The flat, pure-white light at high noon is harsh and "contrasty," washing out colors and robbing your subjects of their three-dimensional qualities. As we've seen, it's the added color in light that enhances any object. When that color is not present, it's tough to make good images.

Typically, photographers spend middays eating lunch, napping, or scouting locations for their sunset shoot. But if your only opportunity to photograph the Grand Canyon presents itself at lunchtime, you'll have to make the most of a bad lighting situation. It's challenging, if not impossible, to make good photographs under such conditions. Adding a warming polarizing filter on your lens can improve the situation to a small degree. It will reduce some of the bright reflections and enrich the colors of your subjects a bit. If given no other options, look for the boldest shadows you can find and try to emphasize them in your composition. Remember, shadows add drama and dimension.

Avoid midday light when photographing people. It is most unflattering for portraits, as it casts deep, ugly shadows around the eye sockets and under the nose and chin. If your portrait can't wait until the sun gets lower, move to a place with open shade. Another alternative is use of a flash attachment or reflector to soften the offending facial shadows.

Avoid shooting in the harsh light of midday. The high, overhead sun casts a poor quality of light that is flat, white, and unflattering to most subjects.

Assignment: *Experiment*

A photographer's education is a lifelong work in progress. As with any craft, we must pay our dues and learn by doing. The late, great photojournalist Henri Cartier-Bresson famously said, "Your first ten thousand photographs are your worst."

By no means are all photographs intended to be "art." Many have been shot purely for the purpose of experimentation, just as fine artists have drawn study sketches before painting a grand masterpiece. It's the best way to figure out what works and what needs work. Learning from mistakes helps you refine your approach, and you'll be better equipped to handle similar situations when they arise in the future.

One of digital photography's greatest advantages is economic. You can shoot as many experimental shots as you like without having to pay extra for every exposure, as we did back in the days of film. Experimentation costs nothing but time, so don't be shy about trying something new or different simply as a deliberate exercise for your own edification. Learning the nuances of light and how it affects the overall presentation in a photograph is part of your ongoing education. The only way to learn how light reacts in various situations is to get out and shoot, and then evaluate your results.

Many people use the small LCD display on the back of the camera to evaluate and edit their images. Don't join them. The small screen is fine for a quick check of basic compositional elements, but don't use the LCD to make critical decisions. It's best to view your images on a calibrated computer monitor where you can scrutinize them in detail at a larger size. Sometimes a composition that seems so perfect on location doesn't look that good when we get back home and view it again with a critical eye. But the upside of experimentation is unlimited. It familiarizes you with the steps of the process, corrects mistakes, and speeds you through your first ten thousand photographs.

What is color?

A brief primer in the properties of color will help you understand its effects on composition, although it's pointless to try to apply any rules here. You don't always get to choose the colors you work with in a photograph, so it's ultimately up to you and your own color sensibilities to incorporate them in ways that you deem appropriate under the circumstances. But color is a vitally important element in photography, so a little background on the inherent characteristics of certain colors is beneficial.

Color is its own justification. It not only makes the photograph better, but at times it *makes* the photograph. It has the curious power to make viewers identify with a scene, even if they've never been there before. And color can induce the same emotional response in many people. The purple in a photograph of a sunset will make almost everyone think of a particular, spectacular sunset they once saw, even though it was quite a different purple and in quite another place.

There has been a tremendous amount of research on the many ways color affects humans. Color's psychological effects are hard to measure, but each of us has color preferences that affect our moods. Some studies suggest that men and women respond to colors differently. Personal reactions aside, some human emotions seem to be generally assigned to certain colors. They can evoke feelings of strength, melancholy, arousal, or joy.

Reactions to some colors also can be influenced by cultural values or regional tastes. For instance, green is regarded as potent and robust in arid countries; white is more highly regarded in Asia

GLOSSARY OF COLOR TERMS

Analogous colors – Colors next to each other on the color wheel. Also referred to as harmonious colors.

Complementary colors – Colors opposite each other on the color wheel. Also referred to as contrasting colors.

Value or tone – Brightness or darkness of a color.

Color relationship – The way colors affect each other in a scene.

Hue – The quality that distinguishes one color from another.

Intensity – Saturation level of a color.

Monochromatic color – Predomination of one color in a photograph with variations only in the values of that color.

Cool color – Includes greens, blues, and violets.

Warm color – Includes yellows, oranges, and reds.

than the West; and yellow has an unusually high value in Thailand, more than anywhere else. But human beings seem to be very much alike when it comes to our perceptions and responses to other colors. Gray is typically regarded as weak, whereas red is almost universally seen as active and powerful. Have you ever heard a man's red necktie referred to as a "power tie?" Blue is accepted as a soothing color by almost everyone around the globe. Those perceptions definitely affect the way we respond to colors in a photograph or painting.

In a sense, color and photography were meant for each other. The vivid red of a cactus blossom and the bright yellow of an aspen leaf owe their richness to the absorption and reflection of light. At its most basic level, photography is the gathering of light in a scene that is then assigned to the pixels of a digital file. Every light source, be it the sun, a fluorescent tube, or a campfire, casts its own color bias on the surrounding area, affecting the apparent color of everything it illuminates. So the answer to the question "What is color?" lies in the nature of light itself.

The most spectacular evidence of the existence of color in light is a rainbow—that spectrum of colors separated by the refraction of sunlight through raindrops. The addition, subtraction, and mixing of the rainbow's three primary colors (red, green, and blue) creates the entire color palette of light in seemingly unlimited permutations.

Analogous versus complementary color

Contrast in black-and-white photography simply refers to the relative difference between the highlights and shadows in a scene. But in color photography, while light and shadow remain important, the relationship and intensity of colors become integral elements of composition.

It's difficult to generalize about the merits of a particular color scheme. There are, however, objective characteristics of analogous colors versus those of complementary colors. Analogous colors are close to each other in value, intensity, and hue and often are referred to as harmonious. Complementary colors, on the

other hand, are in sharp contrast with each other by exhibiting wider-ranging color value, intensity, and hue. Juxtaposing complementary colors creates a clashing vibrancy that differs markedly from the more placid, harmonic appearance of analogous colors.

Complementary colors are those directly opposite one another on the color wheel. When placed side by side, complementary colors intensify each other, making the colors seem more vibrant. Reddish and yellowish hues are often described as warm, suggesting an association with candles, lanterns, and fires. Bluish and greenish hues are considered cool, reminiscent of overcast days and verdant forests.

Warm/cool combinations can add another level of interest to any composition. Research shows that when asked to judge the pleasantness of pairs of colors, people overwhelmingly prefer the commingling of complementary colors. And we have a marked preference for color pairings with the widest contrast differences between them in value and intensity. Although the primary colors of red and green clearly

complement each other, they don't exhibit the sharp contrast of blue against yellow. The balancing of bold complementary colors in a photograph can shake up our expectations and achieve striking effects.

Quite a different mood can be established just as easily by incorporating only analogous colors. Colors that are in harmony with each other are grouped closely together on the color wheel and use only a small portion of the color palette, usually consisting of two colors in unsaturated hues. In the absence of aggressive color, however, it is easier to appreciate fine subtleties between similar hues. Compositions that contain only analogous greens, blues, and purples will have a soothing effect, whereas photographs containing harmonic reds, yellows, and oranges can be energizing.

The warmth of an ocotillo's orange leaves and the cool blue tones of the shadowy background combine in a vibrant scene of complementary colors.

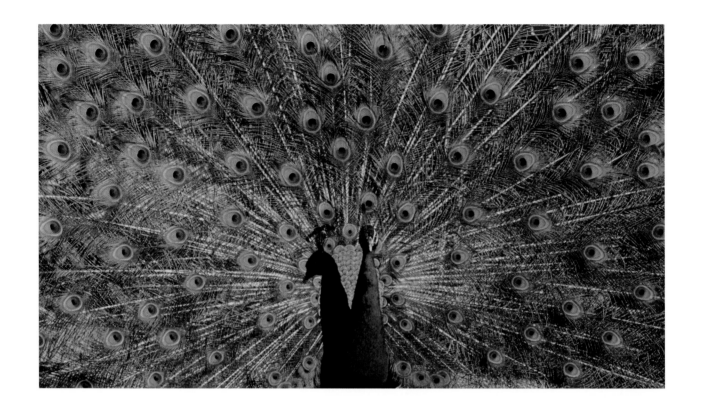

Blue and green hues in the peacock's feathers create a flamboyant image in analogous colors.

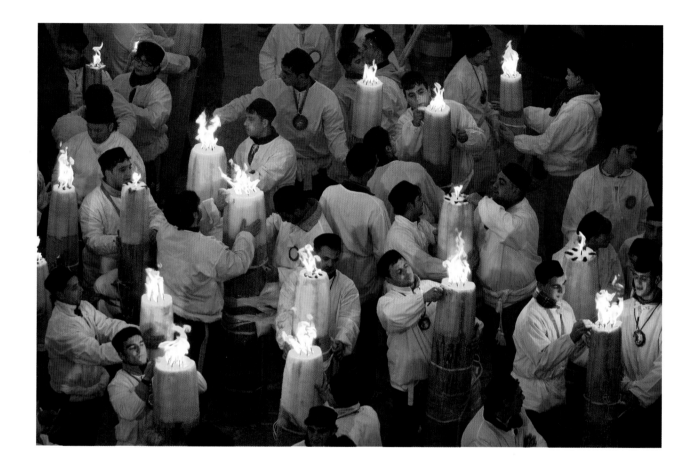

Complementary Colors

The contrast of complementary colors sets up this dramatic street scene of acolytes lighting candles at the Feast of St. Agatha in Sicily. In the gloaming of twilight, there was no direct sunlight on the subjects. The scene is colored only by the bluish cast of light being reflected off the dome of the sky. The acolytes' pure white surplices took on the color of the prevailing light to create a cool background color contrasted against the warmth of candlelight. The tranquility of soft blue is balanced with the aggressiveness of bright yellow.

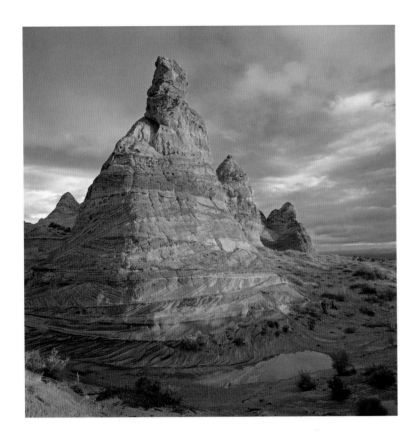

The complementary color of the vivid orange rock formations makes the pale hues of the blue sky appear darker.

Juxtaposition of complementary colors adds interest to a photograph.

Color context

The perception of color in a photograph often depends on its context. An object's color properties will be influenced by its relationships with neighboring colors, and our judgment of hue may be altered by the juxtaposition of certain colors. For instance, a pale color may seem darker in a scene dominated by lighter colors or a vivid color may make the color next to it appear complementary even if it's not. A saturated red will induce a blue-green tint in neighboring colors, for example.

Color need not monopolize a scene to gain attention. Often, the vitality of color depends more on placement than size. Some of the most striking color photographs can turn a small spot of intense color into the focal point of the composition simply by surrounding it in gently harmonious hues.

Most colors look their brightest against a neutral background.

This is particularly true of reds and yellows when played against grays and tans, often giving a three-dimensional effect and turning a drab scene into a splash of color. When sunlight picks out a bright color against a dark, shadowy area, the effect can be doubly dramatic.

Incorporate these color fundamentals in your photographs, but be aware of the effects they have on other elements in your compositions. Adding more color isn't necessarily better. A yellow object may pull attention too strongly or have a jarring influence on an otherwise harmonious scene. In a completely different setting, that same yellow object may be just the focal point your composition needs. Being keenly aware of color's potential impact on a composition will help you utilize it to its best advantage or avoid it completely, if appropriate.

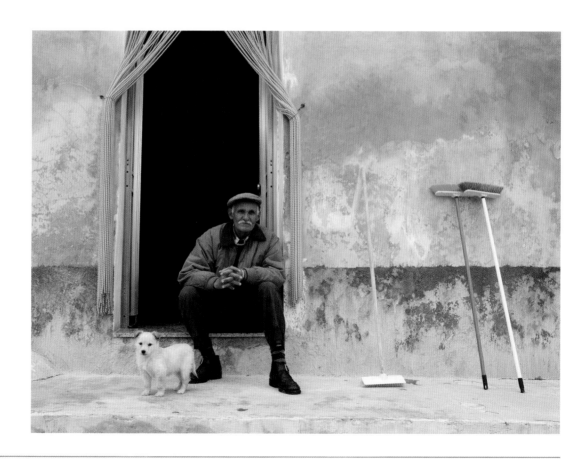

Assignment: Color

With all the vivid colors in our world, the human brain seeks the balance of mid-gray. Each complementary pair of colors combines to make gray. Because we've learned that red and green are complementary, try staring at a red apple for about 15 seconds, and then quickly shift your eyes to a blank sheet of white paper. For a brief instant, your eyes see the image of a green apple because your brain, while staring at the red apple, automatically supplied the green to restore the mid-gray balance. For another color exercise, pick a favorite color and spend a day photographing this color everywhere you encounter it. Look for your color's complementary and analogous colors to pair with it. Experiment with the concepts of dominance, balance, and proportion to see how your color reacts in different situations. The more you understand about the properties of color, the better equipped you'll be to artfully incorporate it into your images.

Splash of Color

The primary colors of the two brooms on the right side of this scene come as a complete surprise, almost glowing out of the otherwise monochromatic surroundings. With only neutral hues of gray, tan, and brown to compete for attention, the relatively small brooms become a focal point in the composition and a counterpoint to the man and his dog.

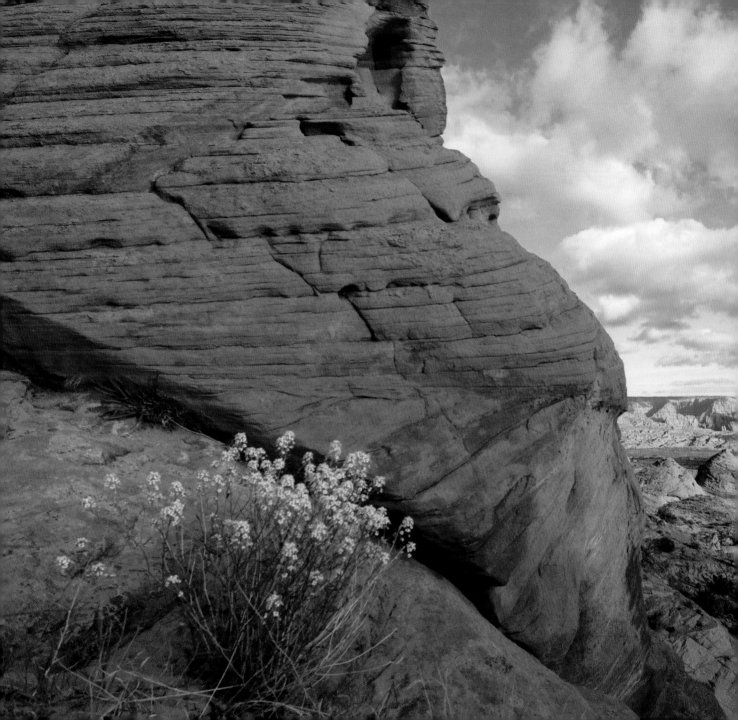

Chapter 3: Viewpoint and Perspective

Clearly defined vision

GOOD COMPOSITION relies on thoughtful selection of subjects and creative use of space. It's the art of presenting your vision in a clear, uncluttered arrangement of shapes, lines, and colors. The challenge is creating the perception of depth in a two-dimensional translation of our three-dimensional world. Selecting and arranging elements in a pleasing composition enhances the sense of space in any photograph. And it's almost entirely dependent on viewpoint and perspective.

Viewpoint is the position of the camera and its angle of view relative to the subject. It can be high or low, left or right, close or distant. Perspective refers to the way objects relate to one another in a composition. It's also heavily influenced by the way objects relate to the lens, affecting the sense of depth and proportion in a photograph. Finding the viewpoint and perspective "sweet spot" is the cornerstone for a balanced composition with

seemly relationships between all compositional elements.

The essence of the photographer's craft is to carve out a small piece of the world and artfully give it a context that supports and advances the narrative of the photograph. That context is contingent on positioning the camera, selecting a lens, and directing its gaze with pinpoint accuracy. Knowing your subject and what you want to say about it also is important. The disposition of compositional elements will either help or hinder the clarity of the message, so you must decide which elements to leave in and which to leave out. The line of decision between in or out is the boundary of your viewfinder's frame.

Renowned landscape photographer Gary Ladd, the foremost authority on photographing the Grand Canyon, had this to say about controlling context: "Photography is a selective stressing of the desirable, and a concealing of the unwanted or unneeded. Landscape photography at its best is an idealization

Selecting the right viewpoint and perspective provides a sense of space to a photograph. Overlapping foreground, middle ground, and background compositional elements creates the illusion of depth.

of reality. It directs our attention away from the ordinary and toward the quietly spectacular."

The story told in a photograph is almost always quoted out of context because no lens is capable of capturing the entirety of a subject's earthly context. Nor would we want such a lens. It's the photographer's purposeful mission to control what an image reveals about the subject, not simply to include whatever fits within the frame (see the discussion of snapshots in Chapter 2). The "language" of visual communication gives photographers the power to shamelessly skew reality or subtly slant the message by merely changing the context surrounding the subject. We have creative license to communicate the story in any way that suits us.

This doesn't mean that you always have to tinker with reality or avoid representing your subjects in an honest and straightforward manner. Photography's history has produced many fine examples of candid, sincere photographs that are considered masterpieces of the medium. But certain techniques that help establish context will make it easier to create images that reflect your personal views about the subject and accurately convey the message you intend.

Familiarity with your subjects is another useful factor in providing the right context for them. Photographers always want to operate from a position of knowledge regarding their subjects. The more you know about your subject, the better you can depict it in proper context, especially if a realistic portrayal of the subject is your goal.

Ansel Adams, arguably the greatest landscape photographer of the 20th century, understood the advantages of being informed. "A good photograph is knowing where to stand," he said. "A great photograph is one that fully expresses what one feels, in the deepest sense, about what is being photographed." Knowledge of your subjects elevates the emotional content of your photography by putting more of yourself into every image.

Vital to selecting a viewpoint and perspective that is appropriate to your subject is having a clearly defined vision of what you want to accomplish in the photograph. You may simply want to make a statement about the subject's beauty, a common theme of many photographs. Or you might decide to show the irony of your subject's situation by juxtaposing it with contrary elements. Through the art of selection, you're able to interpret the same subject in a number of ways. It can be depicted as ornate or simple, serene or dynamic, delicate or powerful, all depending on the camera position and lens you choose.

When you're in the field with your camera, be alert and receptive to all the stimuli around you. This is the time to tap into your imagination, mining for ideas to creatively present your subject. Be sensitive to the rhythms of the moment, and don't get too attached to preconceived notions about the image you are pursuing. Surprises are welcome gifts. Accept them graciously.

Many variables go into the making of a good photograph, but rarely do they all fall perfectly into place, especially if you're photographing outdoors. Nature has a way of changing your plans. Allowing yourself the freedom to respond to situations as they unfold can lead to even better images.

Always operate from a position of knowledge regarding your subjects.

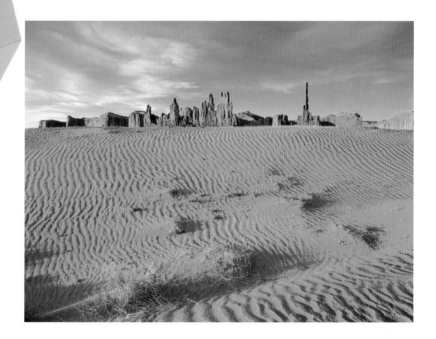

Viewpoint is the position of the camera and its angle of view relative to the subject. Perspective refers to the way objects relate to one another in a composition.

The Illusion of Depth

The challenge of photography is creating the perception of depth in an image. The photographer must decide how much depth is appropriate to the scene and then translate that vision to the final image. In this case, the desired effect was to create a landscape evoking the sense of wide-open spaces in Monument Valley. A low viewpoint and a 24mm wide-angle lens with a downward angle of view combine to produce a perspective that exaggerates the foreground and minimizes the background. This optical effect gives the illusion of distance, depth, and spaciousness.

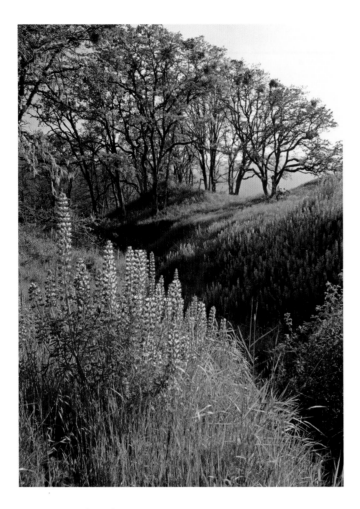

A wide-angle lens and a camera position close to the foreground wildflowers adds to the sense of depth and perspective of this landscape.

The right lens

Lenses come in a broad array of focal lengths that will help you realize your vision. They are generally grouped into three different categories—wide-angle, standard, and telephoto—each with its own inherent qualities that affect the way it "sees." Lens characteristics impose their own view on a scene, so part of the composition process is shaping the lens' view to suit your creative vision.

The lens serves two main purposes in photography. It gathers light from a scene, focusing it onto a common point—the camera's sensor; and it controls the amount of light striking the sensor. The quantity of light passing through the lens is controlled by the size of the aperture in the lens' diaphragm mechanism, often referred to as "f-stop." Aperture is one of the variables, along with shutter speed and ISO, which measures basic image exposure. And, as we'll see later in this chapter, aperture size influences another important factor in composition, depth of field.

Besides focus and exposure control, the lens also adds

its own optical effects to the arrangement of compositional elements. The lens' angle of view carries along with it an optical bias that may make your scene look remarkably different when viewed through a lens because lenses don't work the same way as the human eye. Depending on focal length, lens optics can rearrange lines in a composition and distort the perception of depth and space between objects. Angle of view is the precise measurement of a lens' field of vision. A change in focal length equals a change in the angle of view, measured in degrees. The shorter the focal length, the wider the angle of view.

Because our eyes see things in three dimensions, we have a decided advantage over lenses. Evidence suggests that the human eye has an angle of view of at least 140 degrees, roughly equivalent to a 15mm lens. Of course, our eyes don't come with the accompanying distortion inherent in most wide-angle lenses, but this gives you a point of reference. Getting accustomed to the ways your camera lenses affect spatial relationships is part of the learning curve. Familiarity with the effects of various focal

lengths will serve you well in estimating which lens is best suited to each situation.

Any lens with a focal length of 35mm or less is considered a wide-angle lens, with lenses of 20mm or less known as "ultrawide." The wide-angle lens takes its name from the increased angle of view that it offers. Within the wide-angle classification we find lenses with focal lengths as short as 8mm, including fish-eye lenses with coverage of a full 180-degree angle of view. A primary advantage of wide-angle lenses over lenses with longer focal lengths is their ability to include more of a given perspective within the frame. Another is the increased depth of field they provide.

Distance is exaggerated in scenes when viewed through lenses of short focal length. Everyone is familiar with the warning on a car's sideview mirror, "OBJECTS IN MIRROR ARE CLOSER THAN THEY APPEAR." Convex curvature of the mirror widens its angle of view so we can see all the way across the lane next to us. The perspective created by this curvature distorts the way objects relate to the mirror. It's similar to

the way objects in a composition relate to a wide-angle lens.

Close subjects appear much larger than they do to the naked eye, whereas more distant objects seem to recede into the background. When using wide-angle lenses, be aware of this effect and how it changes with the angle of view. At times, you can take advantage of this effect by incorporating its exaggerated perspective into the scheme of your composition. At others, it may distort objects too much, making it inappropriate to your subject. You must decide how much distortion is too much.

Wide-angle lenses excel on grand landscapes and panoramic views where their angle of view is capable of taking in a wide swath. They relate very well to foregrounds, by exaggerating the size of objects closest to the camera and adding a sense of three-dimensional depth. A common compositional technique known as "near/far" or "forced perspective" places foreground subjects of strong interest extremely close to the camera position, thereby juxtaposing them against other objects or landforms in the background.

This combination of close and distant objects is an effective technique to illustrate spaciousness in a photograph. It presents elements of the vast *and* the intimate in a single image.

Telephoto lenses have just the opposite effect on depth. Their longer focal lengths tend to shrink the apparent distance between objects. Telephotos come in a broad range of focal lengths, from about 70mm to as long as 2000mm, with an angle of view rarely exceeding 40 degrees. The characteristic effects of telephoto lenses are useful for compositions that need to bring distant objects closer. By optically compressing the space between foreground and background, telephotos have the power to artificially flatten the appearance of a scene. The compressing of spatial gaps allows the photographer to create closer relationships or juxtaposition between objects that are otherwise too far-flung to draw a connection. The longer the focal length, the more pronounced the compression effect.

Another inherent quality of long focal length is shallow depth of field. Telephoto lenses are very effective at isolating a subject by defocusing objects in front and behind it. Placement of the subject within a narrow zone of sharp focus makes it the obvious focal point in a composition. Isolating the subject using a shallow depth-of-field technique has the added benefit of simplifying the composition, reducing the number of elements you have to account for, and focusing singular attention on the main subject. It can solve a lot of problems with surroundings that are too busy or chaotic, making the main subject in the composition difficult to identify.

In between the extremes of wide-angle and telephoto lenses are the standard lenses. In the 35mm to 70mm focal length range, they generally cover an angle of view between 40 and 60 degrees. Lenses in the standard category are sometimes called "normal" lenses because their optical makeup comes closest to representing spatial relationships similar to the way our eyes see them. There is nothing remarkable about the realistic perspective they bring to a composition, but among the various focal lengths, standard lenses offer the most versatility.

A normal lens' value lies in its ability to interpret a scene in a way that is faithful to what your eyes see, with little or no distortion of subject and space. Because of their direct and uncomplicated nature, lenses in the standard focal length category are generally a good choice for people photography and portraits. Medium focal lengths also give photographers tighter control over depth of field, depending on what the subject and situation calls for. Using small apertures such as $f/16$ or $f/22$ can keep everything in sharp focus from foreground to background; choosing large apertures such as $f/2.8$ or $f/4$ allows for a much narrower zone of sharpness, selectively focusing on only a small section of the overall scene.

The magic of lens optics empowers you to compose scenes that grab viewers' attention and pull them in for a closer look. Understanding how different focal lengths alter the interpretation of reality lets you see beyond the obvious. Their characteristics and optical effects are tools to help you construct your view of the world. Put lens optics to work for you.

Wide-angle lenses = 8mm to 35mm
Standard lenses = 35mm to 70mm
Telephoto lenses = 70mm to 2000mm

The shorter a lens' focal length, the wider the angle of view.

GET TO KNOW YOUR CAMERA'S IMAGE SENSOR

Digital sensors come in various sizes depending on camera make and model. The size refers to the sensor's physical dimensions, not the number of pixels, and has a profound effect on lens focal length. The combination of image sensor size and lens focal length determines a lens' angle of view. Most high-end DSLR cameras have large full-frame (24 x 36mm) sensors that have no effect on lens focal length or angle of view. But the smaller sensors (15 × 22mm) often used in less expensive cameras multiply a lens' relative focal length and reduce its angle of view. This multiplier effect can turn a wide-angle into a normal lens or a short telephoto into a long telephoto. For example, a smaller sensor with a 1.5 multiplier turns a 24mm lens into 36mm. A 200mm lens becomes 300mm with an accompanying reduction in the lens' angle of view. Consult your camera owner's manual to find your sensor's "crop factor" or multiplier effect.

Telephoto Lens Compression

Telephoto lenses provide photographers the optical power to shrink the distance between foreground and background, creating closer relationships between compositional elements. Here, neighborhood homes on a distant hillside are brought into closer proximity of the church steeples in the foreground using a 300mm lens. A small aperture of f/22 maintains a wide depth of field to keep everything in sharp focus from foreground to background.

Near/far or forced-perspective composition exaggerates the size of foreground objects, juxtaposing them against a harmonious background.

A telephoto lens compresses overlapping formations in Bryce Canyon, creating spatial relationships between otherwise disparate compositional elements.

Finding your viewpoint

So far, we've identified some of the considerations that come into play when choosing your viewpoint or camera position, such as subject, light, and color. These initial assessments can all be done with the naked eye. Once you've established your starting point based on these factors, it's time to refine your viewpoint. Let's begin with the important step of arranging your compositional elements.

Start by identifying the important elements present in the scene you plan to photograph—the prominent objects, lines, and shapes. Then make a preliminary selection of the lens and focal length appropriate to the scope of the scene. Choose a focal length that comes closest to your vision for the scene and frames it the way you imagined it in your mind's eye. Did you visualize a broad panorama or a narrow abstraction from the scene laid out before you? Look through your camera's viewfinder to check your instincts on the camera position and lens you've chosen.

Framing your scene with a zoom lens really pays dividends at this point in the process. Minute adjustments are easily made by zooming in or out to perfect your chosen viewpoint. If framing and arrangement of elements appear similar to your visualization of the scene, set up your tripod and mount the camera on it. If what you see through the viewfinder doesn't move you, continue exploring.

Usually, the first place you set up is not the best. By tweaking camera position and focal length, you can find the sweet spot where all of the composition's important elements fit together harmoniously. Perhaps shifting the camera slightly to the left or right relieves tension created by overlapping elements, or maybe lowering or raising the height of the camera on the tripod will achieve the angle of view that best serves the subject. Sometimes the best viewpoint may be only a step away.

Distribution and arrangement of compositional elements inside that little rectangular frame will determine your next steps in capturing the image. Put your critical eye to work, exploring the scene through the viewfinder. Carefully scrutinize every square centimeter of its space to prevent accidents from showing up in your images. Don't let anything within the frame escape your inspection. Police the area around your subject for any "hand of man" distractions that might pull on the viewer's eye, such as Styrofoam cups, soda cans, or cigarette butts. They can disrupt the flow of your composition and are much easier to physically remove from your scene now than to take them out later using digital methods.

This is also the time to inspect your composition for the visual nuisance known as a "merger." Mergers occur wherever lines intersect in a composition. Normally, a composition contains many of these little intersections where lines cross or tones meet and blend together. Egregious mergers can create an annoying interruption of the viewer's experience, but slight adjustments in camera position will usually eliminate these unsightly tension makers. Most often, minor mergers are of little consequence in the grand scheme of an image, and they're not necessarily always bad. In fact, some mergers can be important to the motion created by the leading lines in a composition. But be aware of their presence and placement, minimizing or eliminating them if they are disruptive.

Often, the most unflattering mergers occur where elements in a composition intersect with the vertical and horizontal edges of the viewfinder's frame. Look for unwanted objects around the periphery such as tree branches or power lines sneaking in at the edges of your scene. Pay particular attention to the corners of the frame. In visual design, the corners of a photograph are considered prime real estate, often reserved for placement of important eye-controlling lines and shadows. To make good use of these areas, don't waste valuable corner space on inconsequential intruders or counterproductive mergers. We'll examine mergers more closely in discussion of leading lines in Chapter 5.

Be deliberate in your assessment of all the lines, shapes, colors, light, and shadows that you have arranged. Make certain that your main subject is predominantly featured with none of the supporting elements encroaching on it. Feel free to experiment with other camera positions, being mindful of lighting conditions and giving priority to the light's interaction with your subject. Survey different angles and observe how the act of changing positions alters spatial relationships between objects in your scene. Even the smallest of incremental changes in viewpoint creates a parallax that can dramatically affect a composition's lighting, balance, and structure.

The most noticeable difference between one viewpoint and another is often the background. Carefully inspect backgrounds, paying close attention to how they affect your subject. A messy background with too much texture or overly complex detail introduces unwanted busyness that interferes with the flow of the composition. If your subject cannot be easily moved to a different setting, options for improving the background are limited. Often, lower camera angles bring the open sky into play, which provides a smooth alternative to a chaotic background. Alternatively, you might utilize a shallow depth-of-field and selective-focus technique, or move the camera to a different viewpoint offering a change in background. We'll explore these solutions more in the "Depth of Field and Focus" section of this chapter.

Consider also that your subject may have more than one good viewpoint. Many photographers, when exploring the potential in a scene, prefer to "work it." That is, they move in and around the scene for an extended period of time, alert to the varying conditions. Changing camera positions in sync with the shifting direction of the light allows you to look for different arrangements of the same elements. Keep in mind that distinct and unusual perspectives can make a photograph more interesting. Try working your scene from several other angles and various lens focal lengths to discover its full potential. This also gives you more options when you get back to the computer with a digital card full of images.

Too often, photographers don't get the most out of a scene because they fail to stick with the situation long enough for it to reach its peak. As the day progresses, highlights and shadows advance and retreat in a constant state of flux. Awareness of changing conditions will keep you and your camera on the move. And even though a zoom lens makes fine-tuning your compositions a breeze, don't rely on it exclusively for compositional adjustments. Use your feet as well to move in closer.

Climb to a higher position or lay on your stomach to get a ground-level perspective. Combining the many variables of viewpoint, lens, and perspective presents an almost unlimited number of options. Sometimes the most obvious viewpoint isn't necessarily the best one. Experimentation with alternatives will lead you to the best vantage points.

Carefully scrutinize every square centimeter within the viewfinder frame to prevent accidents from appearing in your images. Eliminate distractions that pull attention away from your subject.

Mergers

Mergers occur wherever lines intersect or elements overlap in a composition. Although not always bad, be aware of them and eliminate or minimize mergers by tweaking camera position or repositioning your subject. Egregious mergers can occur around people in a photograph, so pay close attention to background objects that appear to be protruding from your subject. Also, be careful of cutting off limbs and tops of people's heads at the edge of the frame. The rule of thumb for photographing people is always crop just above the joint—ankles, knees, or waist.

The corners of a photograph are considered prime real estate, often reserved for placement of important eye-controlling lines and shadows.

Leading lines and geometry add energy to this scene of London Bridge. The diagonal line entering the frame in the upper left corner provides a strong flow to the composition.

Assignment: Viewpoint Parallax

The term "parallax" refers to the apparent change in position of an object when the person looking at the object changes position. To demonstrate the parallax effect, try this simple experiment: Close your left eye and hold your hand out at arm's length with your thumb up. Using only your right eye, visually align your thumb with a distant object such as a tree. Now, holding your thumb in place, close your right eye and open your left. Notice how this throws off the alignment of your thumb and changes its spatial relationship to the tree. This is parallax in action, and the change in viewpoint is only the short distance from one eye to the other. So imagine the parallax shift and accompanying compositional changes that occur by moving your camera to a different position several feet away. Even the smallest of incremental changes in viewpoint will create a parallax that dramatically affects the structure of your composition's spatial relationships and balance.

Unusual perspectives can make a photograph much more interesting.

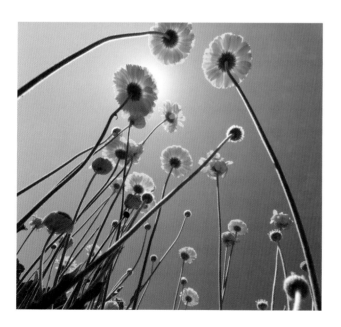

Unusual perspectives add interest to any composition. This bug's-eye-view of desert marigolds was created using a wide-angle lens. The camera was nestled on the ground beneath the flowers before tripping the shutter.

The power of perspective

The concept of perspective is difficult to explain, but we all have experienced it. At its most basic level, photographic perspective is simply the effect that makes one object appear farther away than another. The real world is three-dimensional, having length, width, and depth. Because photographs are two-dimensional representations having only width and length, a sense of depth must be introduced using lens and depth-of-field techniques. In reality, of course, perspective is an optical illusion created by the photographer.

Before we go any further with what perspective is, it may be helpful to understand what perspective is *not*. A common misconception equates perspective with lens focal length. Some people believe that by changing the lens or zooming in and out, they're changing perspective. Not so. The only way to alter perspective is to change viewpoint, essentially moving the camera. Adjusting lens focal length can give you a different view of a scene, but it doesn't affect perspective. If you view the same scene through 10 different focal lengths without changing camera position, the perspective remains the same. When you change focal lengths you are simply changing the framing of your scene.

Finding just the right combination of viewpoint and lens will place you in the best position to control perspective. Perspective, as we've learned, refers to the way compositional elements relate to each other and how, collectively, they relate to the lens. We use the characteristics of perspective to define relationships of size and space in a composition. It's the glue that holds each element in its rightful place, conferring importance on selected parts while downplaying others. The right perspective is the ingredient that turns a composition into considerably more than the sum of its parts.

"Our eyes must constantly measure, evaluate," said famed photojournalist Henri Cartier-Bresson. "We alter our perspective by a slight bending of the knees; we convey the chance meeting of lines by a simple shifting of our heads a thousandth of an inch. We compose almost at the same time we press the shutter, and in placing the camera closer or farther from the subject, we shape the details."

The first and most basic decision affecting perspective is selection of appropriate camera orientation—horizontal or vertical. This is a fairly easy choice. Let the predominant lines of the composition help you decide. If your scene includes a lighthouse, trees, or other tall, upright objects, employ a vertical orientation, also known as "portrait," to take full advantage of their lines. To accommodate subjects with strong horizontal lines, such as roads, fencerows, or a long horizon, choose a horizontal or "landscape" camera orientation. By playing up the long lines in your compositions, you'll avoid wasted space at the edges of the frame.

The frame boundaries are your primary tools in controlling the scope of your composition. Learning to crop your scenes through the viewfinder saves time and pixels. When it comes to framing a scene, cropping correctly in the camera beats lopping off parts of the scene later on the computer. In-camera cropping simply means making sure you have allowed just the right amount of buffer space on the periphery of the scene—no more, no less. Consider moving the camera closer to the subject and

recomposing if too much wasted space exists around the edges.

In an ideal world, every photograph would be perfectly composed and cropped at the time of exposure. In reality, however, many images could use some improvement after the fact. The standard dimensions of an image straight out of the camera are not necessarily the best crop for every composition. Sometimes, trimming off only an inch or two of wasted space at the edges of the frame helps contain the viewer's eye movement, preventing it from drifting into useless areas of a composition. And some compositions cry out for the extreme treatment of a more radical crop into a long, narrow horizontal or vertical. Thoughtful cropping strengthens a mediocre composition by accentuating the predominant lines in the scene. Cropping a photograph is an art in itself and, when skillfully done, can showcase any subject's attributes more prominently. But be aware that cropping an image on your computer using file management software throws away pixels that you can never get back.

You'll make better use of those pixels by doing most of your cropping through the viewfinder and employing all of your frame's pixel dimensions. Make sure to archive your original files and only work on copied files.

Modern photo editing and file management computer programs, such as Photoshop, Aperture, and Lightroom, are powerful tools with a marvelous capability for manipulating any aspect of a digital photograph. The "digital darkroom," as it's called, is another step in the photographic process where digital files can be altered to bring out the full potential in a photograph. It offers you opportunities to make simple adjustments to exposure, color, and contrast, or the ability to rearrange the elements in your compositions and completely remake an image.

Those mastering these programs are capable of turning the mundane into the fantastic and the normal into the bizarre. Modifying a photograph on a computer monitor can be just as artistic and creative as photography itself. But developing a reliance on computer software to correct mistakes made in the field is not good practice. The software is there if you need it, but a photographer's primary goal is to get the composition right in the camera at the time of exposure. Any post-exposure cropping should be identified during the composition process and thoughtfully integrated in your viewfinder technique in the field.

Composing a frame-filling scene through the viewfinder actually gives you as much control over the appearance of the final image as any software. Great effects can be achieved with basic camera gear simply by employing fundamental techniques of sound composition. Using perspective to design a pleasing and harmonious composition makes every pixel count in the overall success of the image.

Intentionally distorting a subject with an extreme lens perspective introduces unusual visual effects similar to the near/far technique discussed earlier. Getting up close to any object with a wide-angle lens, for example, exaggerates and stretches its normal size and shape. It's a fun way to experiment with your lenses and comprehend the effects of different focal lengths. It lets you interpret an old subject in a completely new way. The alternative reality that you create in a photograph has the power to change people's perceptions of

the world. No expensive computer program is necessary.

When you impose your perspective on a scene, camera position and lens focal length should be adjusted to suit perspective. Pay particular attention to the way the foreground and background relate to the other objects. For example, selecting an elevated camera position and a downward angle of view produces a perspective that naturally emphasizes foreground. Opting for a low camera position with an upward angle of view brings more emphasis to the background. Using a straightforward, eye-level camera position tends toward the ordinary and predictable, often bisecting a scene with the horizon line through the middle. As we'll see in Chapter 4, this is not always good for compositional balance and appeal.

Utilizing techniques that express perspective will help you reveal more about the subject, create the illusion of depth, and give your images greater visual impact.

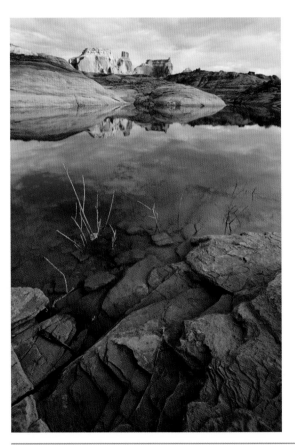

Forced perspective is expressed in this scene using a wide-angle lens and a close camera position to exaggerate the foreground rock. Tilting the camera downward plays up the near/far relationship between the immediate foreground and the distant background.

Perspective

Often, lens focal length is confused with perspective, but the only way to alter perspective is to move the camera to a different position. In this example, we view the same scene through three different focal lengths without moving the camera position. Adjusting focal length or changing lenses provides a very different view by changing the framing of your scene, but perspective remains the same.

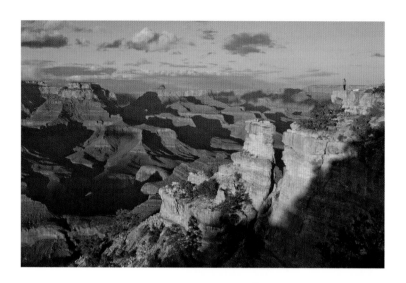

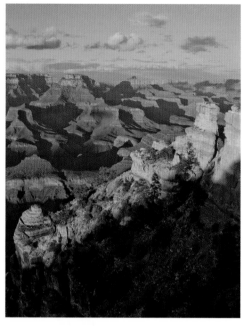

HORIZONTAL VERSUS VERTICAL

Often, professional photographers strive to capture the same scene both horizontally and vertically so they can offer their clients a choice. It always seems to happen that when only a horizontal composition is submitted to the client, the art director invariably calls wanting to know if a vertical version is available, or vice versa. Shooting both orientations of the same scene is not always as simple as turning the camera sideways. It can present a challenging exercise in recomposing. Capturing the vertical version of a predominantly horizontal scene also may require readjustment of camera position and lens focal length to properly rearrange the existing elements into a pleasing composition. But, again, this gives photographers additional options when they get back to their computers to download and edit their images.

In-camera cropping simply means making sure you've allowed exactly the right amount of buffer space on the periphery of the scene—no more, no less. Make adjustments by zooming optically or moving the camera position forward or back.

The Art of Cropping

When skillfully done, cropping plays up the prominent lines and shapes of your composition. Camera manufacturers use standard sensors with uniform dimensions, and images are assigned these dimensions by default. But the image dimensions that come straight out of the camera are not necessarily the best aspect ratio for every composition. Some, as in this example, demand a long, narrow horizontal or vertical crop to accentuate the most powerful parts of a scene. Experiment with cropping your images, but be sure to make adjustments only to copies of your original files. Always archive your originals.

Forced Perspective

Intentionally distorting a subject with an extreme angle of view forces a different perspective and introduces unusual visual effects. Getting up close to this saguaro cactus with a 24mm wide-angle lens exaggerates and stretches its normal size and shape. Lens optics let you interpret old subjects in completely new ways. The alternative reality that you can create in a photograph using basic camera gear has the power to change people's perceptions without resorting to expensive computer programs.

Depth of field and focus

Depth of field and focus play pivotal roles in delineating a visual hierarchy among compositional elements by calling attention to the sharpest parts of a scene. In addition to the integral parts of composition we've already examined—lens, viewpoint, and perspective—depth-of-field techniques provide another means to enhance the perception of depth and bring emphasis to your subjects. Your selection of lens settings for aperture and focus point puts you in direct charge over depth of field in your photographs.

The term "depth of field" defines the floating zone of sharpness around the focus point in a photograph. This distinct zone can expand or contract and move closer or farther away in relation to camera position based on the combination of aperture, focus point, lens, and distance.

"Focus point" is the precise spot in the scene that is selectively chosen to be in sharpest focus, usually your main subject. The subject and anything else at that same distance from the camera will be razor sharp. Be critical with your focus point to make sure the most important elements are in sharpest focus.

Generally, the zone of focus includes an amount of space where objects are only acceptably sharp in front of and behind the focus point. This apparent sharpness is the determining factor in establishing the limits of depth of field. The transition from razor sharp to acceptably sharp is gradual, and the boundaries of the depth of field are not well defined. Objects gradually become more unfocused and blurry the farther they are from the focus point.

Depth of Field

This steer wrestler was photographed using a 400mm telephoto lens, a medium aperture of ƒ/5.6, and focus point about midway between the camera position and the grandstand at the opposite end of the rodeo arena. The result is a razor-sharp subject at the point of focus, which is isolated from the busy background by defocusing the rodeo fans. However, the out-of-focus shapes and elements behind the cowboys are just recognizable enough to help set the scene by adding to the rodeo arena's environment.

The factors discussed in the following sections govern the depth of field in a photograph.

Aperture

This part of the photographic process is affected more by the practical decisions you make than by artistic ones. Depth of field can be strictly managed by tangible changes in aperture size or f-stops. As alluded to earlier in the discussion of lenses, large f-stop numbers—$f/22$, $f/16$, or $f/11$—correspond with smaller apertures that produce the widest depth of field. Small f-stop numbers—$f/2$, $f/2.8$, or $f/4$—correspond with larger apertures producing limited depth of field. Ascending through the f-stops from $f/2.8$ to $f/4$ to $f/5.6$ and so on, depth of field expands in your image with each subsequent click to the next smaller aperture. When you reach $f/22$, you've attained maximum aperture depth of field, depending on the other factors mentioned later.

A 300mm lens at f/7 with a focus point midway into the scene produced this image with only limited depth of field. Flowers in the center of the composition are in sharp focus, while flowers in the foreground and background are out of focus.

Focus point

Focus point represents the spot of sharpest focus. The zone of acceptable sharpness extends to cover about one-third of the space in front of this point, and about two-thirds of the space behind the focus point. Maximum sharpness from foreground to background can be achieved by focusing on a point roughly one-third of the way into a scene using a small aperture. This is known as the "hyperfocal distance," and it offers the photographer a dependable technique for keeping everything in a scene in focus using almost any focal length lens. However, selecting a focus point close to the camera position changes the dynamics of overall scene sharpness by throwing midground and background out of focus, even at smaller aperture settings. Similarly, focusing on a distant object will defocus the foreground. Sometimes achieving the best depth of field requires a compromise among the variables of focus point, aperture, lens, and distance.

In instances where you're unsure of attaining the necessary amount of depth of field for your composition, try bracketing your focus point in the same way photographers use exposure bracketing to assure getting the best exposure. That is, make several identical exposures of the same scene using slightly different focus points. By adjusting focus at various points around your main subject, you'll ensure getting at least one exposure with adequate depth of field.

Focus point at front of scene. Aperture f/ 5.6.

Focus point at front of scene. Aperture f/ 22.

Focus point midway into scene. Aperture f/ 5.6.

Focus point midway into scene. Aperture f/ 22.

Focus point at back of scene. Aperture f/ 5.6

Focus point at back of scene. Aperture f/ 22.

Lens focal length

You can vary the depth of field from any viewpoint by using different focal lengths. A basic guideline to remember is this: Telephoto lenses with longer focal lengths offer inherently shallow depth of field, whereas wide-angle lenses with short focal lengths produce extensive depth of field. Keeping this in mind helps you capture your vision by selecting the right lens for any situation. If your goal is to pick out a small blossom and isolate it from a chaotic thicket, long focal length and large aperture provide a narrow zone of sharp focus to accomplish the desired result. If your plan is to emphasize a cluster of flowers against a harmonious background, short focal length and small aperture will maintain sharpness throughout.

A narrow zone of sharp focus isolates the red Indian paintbrush bloom from the busy background of purple lupine blossoms.

Subject distance

Moving the camera closer to your subjects shrinks the zone of sharp focus. In extreme close-up or macro photography where the front of the lens is mere inches from the subject, the zone of sharp focus can be minimal. At these times, when depth can be measured in millimeters, smaller apertures will expand the zone and add the necessary depth of field to maintain sharpness.

Conversely, focusing on a distant object widens the depth of field with an expanded zone of sharpness. The degree to which your background is out of focus depends not only on the camera's distance from the object but also the object's distance from the background.

Contrary to common thinking, it isn't always necessary to keep everything in your composition sharply focused. Although acute front-to-back sharpness works best for certain styles of photography, such as landscapes, sometimes isolating only the subject in

A macro lens with close-focusing ability allows for much closer camera positions. Here an aperture of f/7 provided enough depth of field to keep the cactus blossoms in sharp focus, but allow the busy background of cactus spines to be softly defocused. Shallow depth of field and background shadows help isolate the vivid red blossoms.

a narrow band of sharp focus is the best composition. Sports and wildlife photography particularly benefit from the subject isolation brought on by selective focus and shallow depth of field.

Because most DSLR camera-and-lens arrays include some form of autofocus (AF), double-checking your focus point safeguards against discovering later that your subject isn't sharp. Don't always assume your AF function has locked onto the focus point you intend. Looking through the camera's viewfinder, position the AF focus area over your subject and depress the shutter button a couple of times to trigger the AF. This fine-tunes your focus point and assures that the AF has locked onto the precise location where sharp focus is most critical in your composition. A small tweaking of the AF can mean the difference between having your subject in or out of focus.

Closely inspect your subject and the other elements of your composition and identify the zone of sharpness. Almost all DSLRs offer a depth-of-field preview button that stops down the lens diaphragm and allows you to see through the viewfinder where the sharpness zone falls at various aperture settings. Use it to check whether the effect is what you want. This function gives you a sneak preview of exactly how your scene will look. If you preview the scene using small apertures, however, the view will appear fairly dark, making it difficult to determine how much depth of field you are actually getting. Be deliberate in your assessment. Once again, familiarity with your photo equipment will benefit you.

You can achieve maximum depth of field in an image with total sharpness from foreground to background and edge to edge by selecting a short focal length, a small aperture, and focusing on infinity. This combination ensures total sharpness throughout the scene. Through experimentation and observing your results, you'll develop a better understanding of the correlation between these factors.

So much of the exposure process on modern DSLRs can be programmed to allow the camera to automatically select appropriate aperture and shutter speed for average exposure. Taking control over these functions yourself is the best way to learn how they affect the outcome of your images. To give yourself the ultimate decision-making power, switch off your camera's automatic or program mode and set it to manual control, which allows you to select aperture and shutter speed. If you're not quite ready to attempt fully manual exposure, try setting your camera's exposure mode to aperture-priority. This option allows you to select the aperture and the camera matches it up with the appropriate shutter speed. This at least allows you more control over an important factor in controlling depth of field in your images.

To gain control over these important steps in controlling depth of field, it helps to know and understand the symbiotic relationship between aperture and shutter speed in the exposure process.

A fast shutter speed of 1/500 of a second was necessary to freeze the hovering hummingbird, but a relatively large aperture of f/3.5 allowed only a shallow depth of field. Flowers closest to the lens are mere inches from the hummer, but are not in focus.

Assignment: Get to know your lenses

Here's a good exercise to learn the characteristics of various focal lengths and their effects on a scene. It's a technique employed by photojournalists who specialize in developing detailed stories about news events. To help tell their stories, they use a variety of lens focal lengths, usually wide angle, standard, and telephoto, from a variety of distances. As you make your approach toward a subject, stop and photograph it using all three focal lengths at each point where you set up your tripod. It forces you to adapt your way of seeing a subject to each focal length.

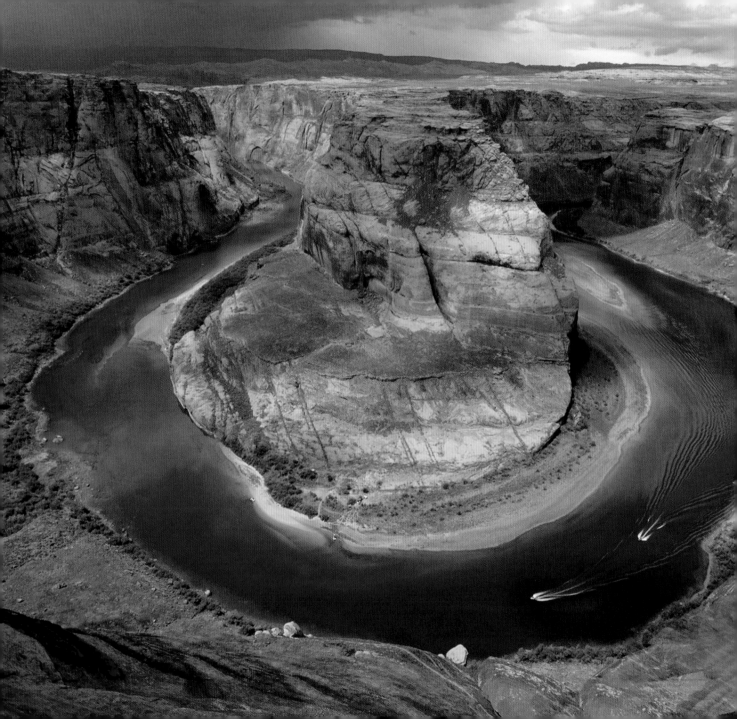

Chapter 4: Rules of Composition

THE PRIMARY ROLE of rules in composition is not precise placement of objects; rather, it's the way rules compel us to compose with a purpose. Giving consideration to these principles engages you in the process and helps you make informed decisions. Their main function is to inspire, not force your vision to conform to the rules.

Art is subjective expression; rules are objective simplifications. Allowing rules to dictate your compositions the same way every time makes your images predictable and formulaic, a terrible fate for any artist. However, artistic rules of conventional composition warrant your attention for good reasons—they lead you in the right direction and produce desired effects in most circumstances. The key is blending the intent of the rules with your own personal vision.

Use rules tactically to achieve balanced design and set your artistic energy in motion. Then, depending on light, subject, and situation, decide the degree to which your compositions should adhere to or deviate from them. There is no right or wrong, so don't feel confined by rules. Only you know best how to arrange the elements in your compositions. In some situations, bending or breaking the rules of convention helps communicate your message in an unconventional way. We'll examine ways to break the rules to good effect in Chapter 6.

Photographer Edward Weston, one of the medium's early masters, once said,

Symmetry and centering of compositional elements in this landscape are thrown slightly out of balance by positioning the two boats off-center. This composition doesn't adhere strictly to the rule of thirds, but it employs the general intent of the rule.

"Now, to consult the rules of composition before making a picture is a little like consulting the law of gravity before going for a walk."

Learning these rules won't tell you what to photograph or how to photograph it, but they provide guidance in designing a pleasing image. View them not so much as imperatives but as good influences for expressing yourself more clearly. Consideration of the rules sets you on a course of choices and actions that can push your compositions toward success.

Rules abound, all purporting to lead you to compositional nirvana. But a few basic principles are all you really need to construct excellent compositions. The goal is to free your mind of restrictions

and technical concerns so you're open and receptive to stimuli around you. Use the rules only for as long as you need them. As your composition skills become more intuitive, visual awareness and recognition increase. With practice and experience, like Edward Weston, you'll no longer need to consult the rules. At the outset, though, rely on these well-established conventions to design balanced compositions that engage the viewer.

Rule of thirds

It's unfortunate that one of the most basic building blocks of good composition has been branded a "rule." The so-called rule of thirds is one of the oldest and most fundamental principles governing composition,

steeped in centuries of art history. But "rule" is a strong word to describe a concept intended more as inspiration than strict dogma. The positive influence it exerts over spatial arrangements is the reason it gets so much attention. The rule of thirds is the syntax of the "language" of visual communication in the same way that rules of grammar help arrange words to form a sentence that's easily understood.

To apply the rule of thirds to any composition, imagine the view through your viewfinder divided into thirds both horizontally and vertically, similar to a tic-tac-toe grid laid over the scene. Use the rule of thirds grid as your guide for the placement of visual elements in your compositions. Place the main subject and other important lines and elements of your composition along the grid lines or near the points where the lines intersect. Some DSLRs offer a viewfinder grid overlay option for those who need a little help visualizing it. Consult your owner's manual.

The beauty of the rule of thirds is in its simplicity, yet it wields significant impact on visual design. The theory behind the rule aids you in assembling a

The key is blending the intent of the rules with your own personal vision.

The main function of rules is to inspire, not force your vision to conform.

balanced array of elements. It's all about visual structure and weight distribution within the frame and establishing visual priorities among the collection of lines, shapes, colors, and textures in your scene. And it helps orchestrate viewer eye movement that encourages exploration of the entire photograph.

The exact center of any composition usually is an unsatisfying place for the eye to come to rest. Without enough implied space for the eye to explore, the viewer's experience is cut short. Centering tends toward the symmetrical or formal arrangement of elements, making the eye less likely to explore the rest of the image because the mind doesn't sense any directional flow to the composition. The rule-of-thirds guideline for off-center placement of the main subject helps avoid the static effects of bull's-eye compositions.

Unfortunately, most DSLR focusing screens contribute to the centering of subjects by placing the AF sensor dead center in the viewfinder frame. This can have the unintended consequence of always positioning your main subject in the middle of your compositions. Check your camera's AF-sensor

mode for alternative placement of the focus sensor in the viewfinder display. If your camera doesn't offer focus-area display options, use the focus-lock function by partially depressing the shutter button to hold the focus point on your main subject. Continue holding the focus-lock button down while you recompose your scene within the viewfinder, positioning the subject at one of the grid points before capturing the image. This sequence works best when handholding the camera and requires a bit more manual dexterity when the camera is mounted on a tripod.

Successful center-weighted compositions are not impossible to achieve, but they require skillful technique to overcome their static tendencies. In situations where the arrangement of elements supports symmetrical composition, centered-subject placement should be balanced by smaller satellite elements at strategic locations around the main subject. They bring energy to a composition by stimulating eye movement between the subject and its surrounding foils. To avoid confusing the story being told, these adjacent elements also should complement the

subject and harmonize with the theme of your photograph.

Probably the most common compositional element photographers must deal with is the predominant line of the horizon. Often, without much thought, the horizon line is allowed to bisect the scene precisely through the middle, giving up the lower half of the frame to foreground and the upper half to sky. Although situations may arise when splitting a scene in half with the horizon line is appropriate, more often it leads to static, uninspiring compositions, and it wastes space around the edges of the frame.

Placing the horizon near one of the horizontal lines of the rule-of-thirds grid raises or lowers the horizon line in the frame. A high horizon line allows you to emphasize an interesting foreground; a low horizon will feature a dramatic sky. In situations where skies have no added interest, such as overcast conditions or cloudless blue skies, it's okay to raise the horizon line very near the top of the frame, allowing only a sliver of sky for context. Conversely, if your foreground offers little compositional interest or if the sky is particularly dramatic, try moving the horizon line

close to the bottom of the frame to play up the best parts of your scene. These techniques work for both horizontal and vertical camera orientations.

Without question, the most important job of the rule of thirds is creating a sense of balance and proportion among all the elements in a composition. Use the grid's vertical lines to help you position the main subject and subordinate objects on opposite sides of your compositions. This alignment creates a desirable asymmetrical balance and makes full use of the frame's space.

Balance implies that the elements within the frame have a sense of visual weight. Larger objects obviously outweigh smaller objects, and dark or saturated objects weigh more than lighter colored ones. The positioning of each element and its proportional relationships to other elements is critical to the visual hierarchy within the composition. It communicates to the viewer what's most important in your photograph.

We consciously assume the center of the composition represents the fulcrum point on our visual scale. Placing a heavy weight (the main subject) on one side of the fulcrum balances well with lighter elements (subordinate objects) on the other side, especially if the lighter elements are positioned a greater distance from the fulcrum. This produces the classic asymmetrical design in a composition.

Proportional balance is an important aspect of design, expressing the symbolism of variety or abundance. Decisions on size and placement of objects along the thirds grid determine the amount of emphasis bestowed on each. A certain amount of imbalance or asymmetry usually makes for better design. The choices you make affect the degree of balance exhibited in your scene. Remaining faithful to your vision and the intended theme of your photograph will guide you in these decisions.

Employing the rule of thirds puts your intuitive powers and instincts to work deciding how best to visually tell your story. Prominent placement of your main subject on one of the thirds lines gives you the remaining two-thirds of the frame to provide balance and flow to the image and bring context to your subject. The rule of thirds helps you use that space wisely. Its premise not only avoids symmetrical compositions, but it also provides a pleasing proportion of space around the main subject and prevents distracting tension between the main subject and the edges of the frame.

The grid guidelines can help you organize the components in any scene. However, positioning objects along the gridlines only jumpstarts the composing process. Then your own sensibilities should take over in deciding the ultimate arrangement of elements. When you begin to see the rule of thirds as descriptive rather than prescriptive, you'll be able to invoke its intent without thinking about its restrictions.

Tip: Symmetrical composition arrangements are tranquil; asymmetrical arrangements have energy.

RULE-OF-THIRDS GRID

To apply the rule of thirds to any composition, imagine the view through your viewfinder divided into thirds both horizontally and vertically, similar to a tic-tac-toe grid laid over the scene. Use the rule-of-thirds grid as your guide for placement of visual elements in your compositions. Place the main subject and other important lines and elements of your composition along the grid lines or near the points where the lines intersect.

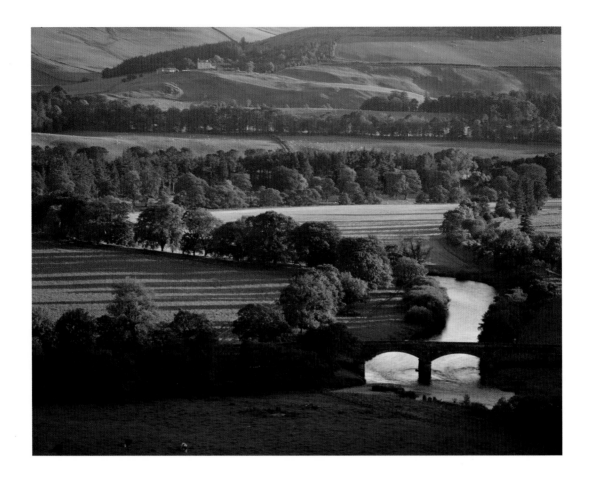

Off-Center Subject Placement

A composition's exact center usually is an unsatisfying place for the eye to come to rest. Centering of the main subject tends toward the symmetrical arrangement of elements. This has the overall effect of suppressing the energy in a photograph, making the eye less likely to explore the rest of the image. Lacking other compositional elements to create motion, the eye doesn't sense any direction to follow. The rule-of-thirds guideline for off-center placement of the main subject helps avoid the static effects of bull's-eye compositions.

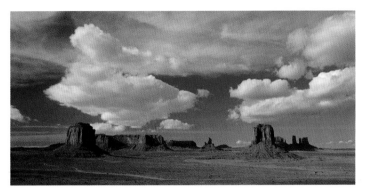

Intentionally lowering the horizon in this composition allows the dramatic sky to dominate the scene.

Raising the horizon plays up the strength of the foreground textures, allowing the pattern of ripples in the sand dune to add energy to the composition.

Asymmetry, or off-center balance, is best achieved by featuring the main subject on one side of the composition's fulcrum point balanced against a secondary subject or other supporting elements at a comfortable distance.

PROPORTION, VARIETY, AND ABUNDANCE

Proportional balance is an important aspect of design, expressing the symbolism of variety or abundance. Decisions on size and place-ment of objects along the thirds grid determine the amount of emphasis bestowed on each. A certain amount of imbalance or asymmetry usually makes for better design. The choices you make affect the degree of balance exhibited in your scene. Remaining faithful to your vision and the intended theme of your photograph will guide you in these decisions.

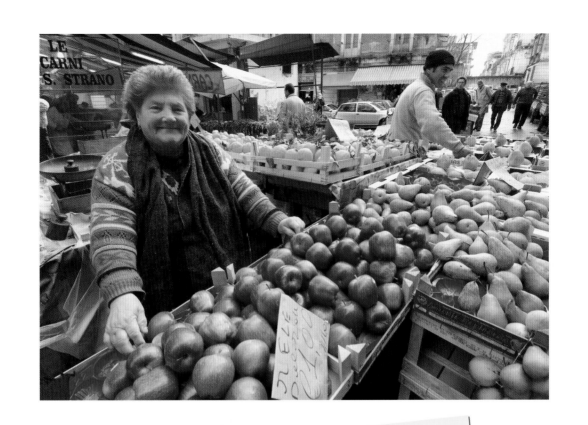

Abundance is emphasized in the asymmetry of this Sicilian street market scene. Note the off-center balance of the main subject (the woman) on the left side played against the secondary subject (the man) on the right.

New horizons

Where to place the horizon line is an important decision for a common compositional element. Normally, bisecting the scene precisely through the middle isn't the best use of space. Giving up the frame to equal parts sky and foreground results in static symmetry. However, there are exceptions when splitting a scene in half with the horizon line is appropriate. Here, the mirrored reflection is tailor made for symmetrical composition.

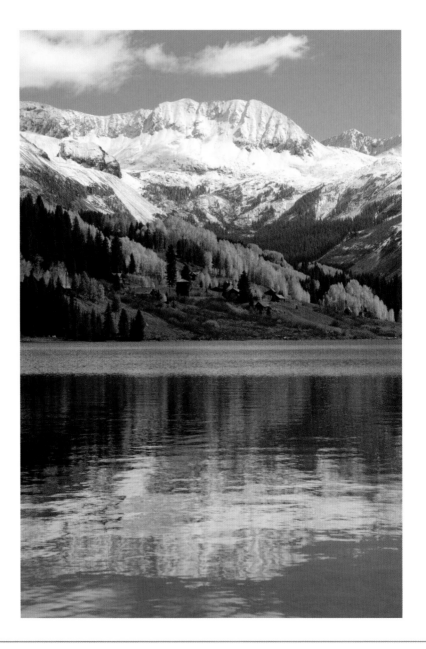

Rule of space

The rule of space mainly applies to compositions with animate subjects or subjects in motion. The principle behind the rule calls for open space to accommodate the subject's leading direction toward the majority of the space within the frame. It's similar to the rule of thirds in that the theory is to create an area in front of the subject so it flows into openness, rather than allowing the edge of the frame or other compositional elements to encroach on it. If the subject faces left, allow roughly two-thirds of the frame to the left of the subject; if the subject leads to the right, open up two-thirds of the frame's area on the right side.

Succinctly stated, allow your subject to face into the biggest portion of the frame. In photography jargon it's known as "nose room," that buffer of open space in front of the subject's nose. Insufficient nose room can create tension if the subject is too close to other objects or too near the edge of the frame.

A moving subject should have ample space in front of it. If your subject is in motion across the frame, the rule of space helps sell the illusion of movement in a still photograph. It calls for positioning your subject in the scene with the shorter part of the frame behind it and adequate room in front for it to move in the leading direction. This is especially important where combining slow shutter speed and a panning camera motion to create a blur of the subject's action. A moving subject that approaches too close to the frame's edge may appear as if it's about to run out of the frame, which creates unnecessary tension for the viewer.

The rule of space stems from the predominant left-to-right rule of the Western world, although this rule isn't concerned about symmetry or asymmetry. The human brain seems to enjoy a little surprise. When we discover symmetry in situations where it isn't expected, or if we find symmetry missing from places where it's anticipated, our eyes dwell longer to reconcile the situation and take pleasure in the irony.

MOVING SUBJECTS

A moving subject should have ample space in front of it. This is especially important when combining slow shutter speed and a panning camera motion to create a blur of the subject's action. Here, thoroughbreds race toward the finish line in a frenzy of action. Cropping the image into a long, narrow horizontal contains the eye and helps create the illusion of movement. Allowing plenty of space in front of the horses gives them room to run without forcing tension at the right side of the frame.

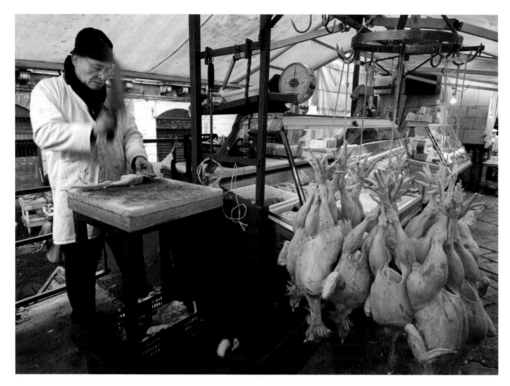

Here, the poultry butcher's leading direction flows into the majority of the composition's space by positioning him at the left side of the frame.

Rule of Space

The principle behind the rule of space calls for ample space to accommodate the subject's leading direction within the frame. The theory is to create an area in front of the subject so it flows into the rest of the composition rather than allowing the edge of the frame or other compositional elements to encroach on it. If the subject faces left, allow roughly two-thirds of the frame to the left of the subject; if the subject leads to the right, open up two-thirds of the frame's area on the right side.

Rule of odds

As its name suggests, the rule of odds calls for an odd number of objects featured in compositions. The design principle behind the rule is based on the idea that grouping elements in odd numbers is more interesting and aesthetically appealing. Even numbers of objects add symmetry, which we know reduces the energy level in a composition.

The rule of odds adds a level of geometry to visual design that finds discord in odd-numbered relationships. Though conflict and tension are inherent in odd numbers, those qualities become more exciting and compelling as a result of the discord they create. On the flip side, an even number of objects resolves conflict, casting a mood of calm and serenity over a composition.

Many aspects of the visual and performing arts—interior design, painting, graphic arts, floral design, landscaping, and dance—lean heavily on the rule of odds principles for basic subject arrangement. There's a psychology to odd numbers that also applies in business and product pricing. A price point of $9.99 is more appealing even though the customer's brain naturally rounds up the price to $10.00. And the next time you order an appetizer in a restaurant, notice that they generally come three or five appetizers per plate.

According to the rule of odds, it's also preferable to include an odd number of repeating shapes or subjects in a photograph. Usually, repetition of three objects is ideal because a triangular eye flow is more natural than any other geometric shape. Once again, asymmetry wins out over symmetry in composition.

A photograph featuring a person as the main subject and surrounded or framed by two other people is more likely to be perceived as friendly and comforting by the viewer than an image of a single person with no significant surroundings. It's fair to conclude that the eye favors the geometry and structure of compositions utilizing odd-numbered groupings of design elements.

The geometry of three running baseball players utilizes the strength of an odd-numbered grouping of compositional elements.

PEOPLE IN THREES

The eye favors geometry and structure utilizing odd-numbered groupings of design elements, especially in compositions featuring a person as the main subject surrounded by two other people. Here, an animated discussion outside a café becomes a classic triangle of human subjects silhouetted in the warm light of a street lamp.

Gestalt theory

In the larger sense, gestalt theory defines a complex set of abstract "laws" of perception and behavior that, when integrated, form a whole that is greater than the sum of stimuli and response. Before your eyes start to glaze over, rest assured that Koffka's treatise on gestalt psychology is not required reading for photographers.

But despite its intimidating sound and the serious academic principles behind gestalt theory, it's a concept that's easy to grasp. You've practiced it most of your life without knowing it.

Gestalt is a German word meaning "shape." Early 20th-century German psychologists developed gestalt theory to describe the human brain's innate self-organizing tendencies, seeking wholeness in the way we view the world. It has important implications in the visual arts, but you don't need a Ph.D. in psychology to understand it.

Gestalt theory applies to common, everyday activities. In fact, you're doing it right now. Reading is a perfect example of gestalt. The gestalt process is activated when your eyes see letter groupings that form recognizable words. Your brain quickly makes judgments about similarity and organizes the words into the overall thought communicated by the sentence.

Another example of gestalt is the perception of recognizable shapes where they don't actually exist, such as seeing the figure of an animal in the billows of a cloud. Then there's the infamous

Gestalt theory at work

Gestalt theory accounts for our ability to read over typographical errors yet still comprehend the intended meaning of the words. Because this book's editors found and corrected (we hope!) all the spelling errors introduced by the author, we'll intentionally create a few typos in this sentence:

Yuor ablitiy to raed and undrestnad this sentnece is an exapmle of gesatlt thoery at wrok.

Even though the letters are not properly arranged, your brain quickly and easily makes sense of the jumbled words and understands the statement as a whole, rather than slowly deciphering it phonetically, one letter at a time, and wondering what it all means. That's the essence of gestalt. It's why copyediting and proofreading jobs require the special talents of someone who can overcome the brain's natural tendency to mask errors and finish incomplete structure.

case of the woman in a Nashville coffee shop who perceived the image of Mother Teresa in her cinnamon roll. Her brain filled in the missing elements in a collection of shapes made of dough, icing, and cinnamon to create a visual whole that her mind's eye recognized as Mother Teresa's face. Others have perceived the image of Jesus in a tortilla and the likeness of the Virgin Mary in a grilled cheese sandwich. All of these incidents involve a little imagination and a lot of gestalt.

In its photography application, gestalt's theory of form posits the idea that our brains easily recognize the visual entirety contained in a composition of organized pieces. Gestalt brings a holistic approach to composition, theorizing that the whole of all elements in a scene is greater than the sum of its parts. It makes no judgment about the quality of a photograph, but it has a lot to say about our ability to perceive the elements in a composition. It can help us to visually complete the shape and essence of an object that isn't entirely visible in a photograph in the same way that it helps us to unscramble the misspelled words in the example presented at left.

In theory, the gestalt effect enables the mind's eye to complete an entity's unfinished form by visual recognition. In practice, it relieves photographers of the need to be overly explicit in the interpretation of a scene. A successful photograph doesn't necessarily need to reveal everything at first glance. Gestalt provides incentive for structural economy in composition.

You can count on gestalt to assist the viewers of your images, too. Holding back some information forces the viewer's imagination to complete the story or solve the conundrum. The principles of gestalt let photographers get closer to their subjects, even allowing parts of a composition to bleed out of the frame without diminishing the information conveyed in the photograph. With only a portion of an object visible within the frame, the viewer's brain relies on memory to automatically finish its shape and form. The mind's eye fills in the missing information thanks to the brain's instant recall of past experiences held in memory.

Ultimately, some degree of mystery or obscurity adds to the intrigue in a photograph. It nudges the viewer into a deeper mental involvement with the narrative.

In short, don't oversell the story by being too literal in your presentation of the subject. The level of interest increases when a composition encourages the viewer to resolve at least part of the story. It gives observers the satisfaction of solving the mystery or providing their own punch line.

Gestalt theory leaves room for the viewers to draw on their own experiences to fill in the unfinished portions, rather than rely on the obvious assembly of elements to spell it out for them. And it opens the door to multiple interpretations of the story presented in a photograph, based on each individual's own experience and perspective.

Joel Meyerowitz, the only photographer allowed unrestricted access to Ground Zero immediately following the 9/11 attack on the World Trade Center, astutely observed, "You fill up the frame with feelings, energy, discovery, and risk, and leave room enough for someone else to get in there."

The best photographs of all time—those considered prime examples of the medium's potential—always seem to leave an unanswered question or a subtle opening with just enough room for viewer interpretation. Whenever a photograph allows the viewer to get involved in its narrative, personal and emotional connections are elevated.

A panda takes shape without all the details present. The brain fills in the missing parts to complete a recognizable form.

Gestalt theory describes the human brain's innate self-organizing tendencies, seeking wholeness in the way we view the world.

Do you see a shapely vase or two people face to face?

ECONOMY OF STRUCTURE

Imagine shooting a portrait of a cowboy wearing a wide-brimmed, 10-gallon hat. The natural impulse is to back away from the subject in order to include the entire hat within the viewfinder. However, using gestalt theory as your guide, moving in closer to the cowboy and cropping off parts of the hat's crown and brim allows them to bleed out of the frame at the top and sides. Because we know from memory what a cowboy hat looks like, we don't need to actually see it all to complete the image. Our brains satisfy the need to complete the missing shape and form of the hat on the basis of familiarity. He is easily identifiable as a cowboy even though his hat is partially removed from view. But because the camera is now closer to the subject, the cowboy's face rightfully becomes the focal point of the photograph, nearly filling the frame. Getting closer plays up details in his eyes and face, revealing more about his character.

In theory, the gestalt effect enables the mind's eye to complete an entity's unfinished form by visual recognition. In practice, it relieves photographers of the need to be overly explicit in the interpretation of a scene.

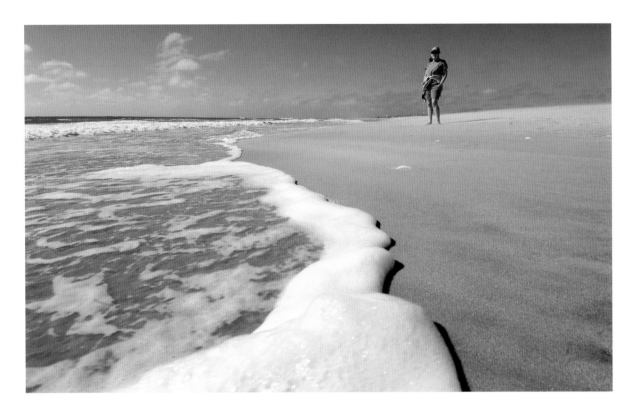

A wide-angle lens and a very low viewpoint exaggerate the foamy edge of an incoming wave, providing a unique perspective and a leading line to take the viewer's eye deeper into the scene.

So now you see how the rules of conventional composition suggest ways to focus your vision more clearly and introduce artistic qualities to your photographs. Every photographer should learn the basic concepts and understand the accepted principles of visual design. But no rule is universal, so apply these rules when appropriate without becoming a slave to them. Rather, look at these rules as tools to help perfect your view. Following the rules won't guarantee a pleasing composition every time, but their rigid application will certainly stifle your creativity if used as a template. Knowing the *reasons* behind the rules makes them valuable tools in your visual arsenal.

Quick composition tips

- Make consideration for light direction a top priority in composition.

- Select the closest viewpoint that reveals the subject's characteristics and makes best use of its surrounding elements.

- Use the rule of thirds for balance and off-center placement of the main subject.

- Arrange compositional elements to give the main subject visual dominance.

- Keep image design simple. Moving closer reduces the number of compositional elements and eliminates distractions.

- Enhance the perception of depth by composing with a foreground, middle ground, and background of overlapping elements.

- Diagonal lines are more dynamic than horizontal lines. Use diagonals to lead the eye.

- Utilize corner space to bring leading lines into the composition.

- Keep visual distractions away from the corners and edges of the frame.

- Be mindful of depth of field and subject sharpness.

- Eliminate bright or white areas that pull attention away from the main subject.

- Light is more attractive than dark. Difference is more striking than conformity.

- Look for repeating patterns and shapes that add texture to a scene.

- Watch out for counterproductive or egregious mergers.

- Overly literal or explicit representations of a subject can turn out boring and tedious. Strive for the ironic, the unusual, or the unexpected.

Strong directional light rims the subjects to create a compelling scene at the state fair.

Chapter 5: Leading Lines

TAKE TIME TO look around, and you'll notice that we live in a world abundant in geometry. Everywhere you turn, lines are on display in all forms and sizes—straight, curved, diagonal, vertical, horizontal, and even zigzag. And sometimes, if you look closely, you'll discover linear arrangements of objects that form implied lines. Whether real or illusory, these lines play an important role in controlling viewer eye movement in composition.

No other compositional device influences flow and energy in a photograph like a strong leading line. Our eyes have a natural tendency to lock onto and follow a line to its conclusion. Lines act as visual connectors between one part of a composition and another. This ability makes them powerful tools that, when strategically incorporated, are capable of delivering the viewer's eye to the main subject with precision and grace.

Some lines are as obvious and permanent as a mountain against the sky. Others are subtle and ephemeral. They can suddenly appear out of an alignment of objects and, just as quickly, disappear with the slightest change in perspective. A strong leading line could be the arc of a rainbow, the angle of a picket fence, or the graceful meander of a stream. Useful lines can appear from just about anywhere if you pay attention to the geometrical elements all around you.

A picket fence forms a strong leading diagonal line coming out of the lower right corner, directing the eye into the scene and delivering the viewer to the composition's focal point and main subject, Ocracoke Lighthouse.

Every leading line may not necessarily stand out as a continuous strand or stroke. Sometimes an alignment of unconnected repeating shapes produces the illusion of a line, such as footprints in fresh snow. Our brains easily make implied connections from one to the next, moving the eyes along on a succession of visual stepping-stones to a destination.

The alignment of visually connected objects can suggest a linear path. Working to find the apposite perspective that creates the perception of a leading line can be crucial to moving the eye along your preferred route. Make it your business to search out and discover these lines and look for ways to incorporate them into your photographs. By positioning your focal point somewhere along the course of a leading line, the composition culminates in a visual payoff for the viewer. It's the satisfying reward for following the progression of a line.

Learning to visualize predominant and subtle lines while blocking out all other elements may be difficult at first. It goes back to awareness, requiring perception and discipline in much the same way as developing your awareness of light. Being able to break down a scene into its dominant compositional lines and angles helps you anticipate their impacts on flow, movement, and energy in a scene. Lines at right angles create tranquility; oblique angles generate motion.

Besides leading lines, other techniques exist to incorporate eye control and motion, such as framing devices that help bring attention to your subject. Here are some common ways to use lines that help build more energy into your compositions.

Lines act as visual connectors between one part of a composition and another.

LEADING LINES

Lines can appear where you least expect them. When this deer walked into the meadow of tall grass, no leading lines were apparent. But by waiting patiently as the deer reached the lake to get a drink, the photographer suddenly became aware that the leading lines of the lake's edge were coming into play. A long telephoto lens was employed to zoom in closer and simplify the scene, eliminating the forest clutter and reducing the composition to only three elements—the deer, the lake, and the grassy meadow. The camera was positioned to allow the diagonal leading lines of the lake's edge to enter the scene from the upper and lower right corners, placing the subject at the point where the two leading lines of the lake edge converge.

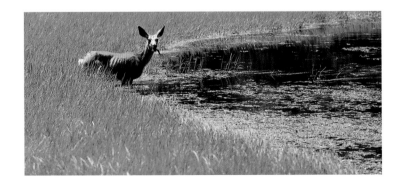

Multiple neutral mergers and near mergers occur in this scene of a regatta below Golden Gate Bridge. Sailboat masts merge with the bridge's deck and cables, and the foreground sailboats very nearly merge with those in the background.

Mergers

Mergers consist of intersecting lines, overlapping tones, or other contact points where compositional elements meet. A scene can contain many such intersections, so keen awareness of them helps you alleviate their negative effects. Identifying the "good" mergers, "neutral" mergers, and "bad" mergers is an important step in choosing the right viewpoint and perspective.

Good mergers advance the theme of a photograph and keep the viewer's eye moving in the right direction. They exert positive influences on the arrangement of elements, forming visual bonds between key parts of a composition. It helps to have a few overlapping elements from the foreground, middle ground, and background to create the illusion of depth and lead the viewer's eye into the photograph. Good mergers make smooth transitions from one object to another.

Neutral mergers occur in places that neither harm nor help a composition's flow. They simply exist, quietly blending with their surroundings, allowing the eye to skip over them easily and without notice. In the grand scheme of the overall composition, minor mergers are of little consequence.

Bad mergers, on the other hand, are an affront to the energy and motion in a photograph. They create jarring collisions between two or more compositional elements, interrupting the desired eye movement or adversely changing the motion. Bad mergers snag the eye and trip up the viewer along the route to the main subject, and they may even redirect the viewer's eye onto an unintended path that destroys continuity within an image. They should be accounted for and the tension relieved wherever they appear.

Scrutinize the scene in your viewfinder looking for disruptive abutments among the collection of lines, objects, colors, shadows, and highlights. Make sure you're aware of the presence and placement of all mergers, and minimize or eliminate them if they are unsightly tension makers. To avoid distractions caused by clashing mergers, try to keep any overlapping elements as simple as possible, and position them in areas that are a safe distance away from the main subject. Often, tweaking adjustments to your camera position or perspective can alleviate mergers.

One of the worst-case examples of a bad merger occurs when photographing people. Allowing a tree trunk, power pole, jet contrail, or other background object to appear to protrude from a person's head is a cardinal sin. And they normally can be easily eliminated with a shift in camera position or repositioning of your subject.

Another merger of sorts, known as a "near merger," occurs where lines or compositional elements add their own degree of good tension simply by their close proximity to each other. It isn't always necessary for objects to intersect or overlap to create tension. They forge relationships by invading each other's space without actually touching. Intentionally allowing elements to form tension-making bonds, yet still allowing a clear separation between them, can be good for viewer involvement by inviting the eye to investigate the composition more closely.

Tweaking adjustments to your camera position and perspective can alleviate mergers.

MERGER MANIA

See how many mergers you can count in this photograph. Mergers consist of intersecting lines, overlapping tones, or other contact points where compositional elements meet. Edge mergers occur where lines and compositional elements intersect with the frame boundaries. At first glance, the agave's fronds created chaos in a jumble of lines and overlapping tones of green. Finding just the right angle of view with adequate depth of field required about 20 minutes of tweaking camera position, focal length, and aperture. Persistence led to the discovery of the best perspective where chaos turned to harmony, making sense of a difficult subject.

The Good, the Bad, and the Neutral

- *Good mergers help advance the theme of a photograph and keep the viewer's eye moving in the right direction. They exert positive influences on the arrangement of elements, forming visual bonds between key parts of a composition.*

- *Bad mergers are an affront to the flow of a composition. They create jarring collisions between two or more compositional elements, interrupting the desired eye movement or adversely changing the motion.*

- *Neutral mergers occur in places that neither help nor harm a composition's flow. They simply exist, quietly blending with their surroundings, allowing the eye to skip over them easily and without notice.*

Frame boundaries

The edges of your camera's viewfinder frame are of utmost importance to your composition. They dictate what's in and what's out of the frame, and they define how elements relate to each other within the confines of its borders. Even in the simplest of compositions, you still must account for the two horizontal and two vertical lines that form the boundaries of the rectangular frame.

Several border mergers occur in nearly all compositions, and dealing with them presents special circumstances. No matter how carefully you compose, lines and other compositional objects invariably meet or bleed out at the frame's boundaries, creating mergers of varying degrees. As with most compositional elements, you must decide to keep an object in or leave it out based on its contribution to the overall story.

Choosing to place an object partially in and partially out creates a border merger that's either good or bad, depending on the amount of tension it introduces to the scene. If you decide to allow an element to bleed out of the frame, be sure to include enough of it inside the frame so that it

contributes to the composition. Remembering gestalt theory, you don't need to show the entire tree, rock, or branch, but an ample portion of the object needs to be visible for the viewer to identify it. Then the brain takes over to furnish the rest of the object's form. Unrecognizable and disembodied objects extending into the frame cause confusion and needless distraction.

Again, it's the bad mergers that require most of your attention, especially when photographing people. A common merger *faux pas* occurs when the edges of the frame cut off feet, hands, or tops of heads. Avoid these awful mergers by allowing a small buffer of space between your subjects and the edge of the frame. There is a generally accepted rule of thumb for cropping the human figure (also know as the "amputee rule") with the edge of the frame: Don't cut off limbs below the second joint. For legs, crop between hip and knee joints, not between knee and ankle; for arms, crop between shoulder and elbow, not between elbow and wrist. Of course, as with all rules of photography, follow your own vision and do what's right for each situation.

Not all edge mergers are bad. Some are unavoidable, but make sure that lines and other elements exiting the frame don't create distracting tension. The horizon line is prone to creating two edge merges in every composition, especially in landscape photography, where it intersects with the left and right sides of the frame. Be mindful of the disruptive effects this dominant line can have on flow and energy. Strategically placing other compositional elements along the horizon line helps camouflage its entry and exit points, breaking it into shorter segments and diminishing its negative tendencies.

Look for distracting objects around the periphery of your scene where unwanted objects can sneak in. Pay particular attention to the corners of the frame and put them to good use. Leading lines entering the scene from the corner areas of the frame create positive motion. As mentioned earlier, corners are considered valuable real estate reserved for placement of eye-controlling elements. Don't allow inconsequential intruders or counterproductive mergers to waste valuable corner space.

Aspen trunks form good mergers with the edges of the frame. Careful composition makes good use of corner space, allowing the converging lines of the trunks to enter the scene from the corners and lead the viewer's eye to the colorful autumn leaves at the center of the composition.

Choosing to place an object partially in and partially out creates a border merger that's either good or bad, depending on the amount of tension it introduces to the scene.

All about lines

Although the truck is the main subject of this photograph, lines dominate the simplicity of the composition. Working in the low cross light of early evening created highlights and shadows that form strong textures in the lines of the furrowed field. Employing the rule of thirds, the road was placed high in the scene and the truck is left of center, allowing it to move into the open two-thirds of the frame's space on the right. The dominance of the static horizontal line of the road is overwhelmed by all the energy generated by the truck's motion and the repetitious pattern of the furrows.

Leading lines entering the scene from the corner areas of the frame create positive motion.

Leading lines of the dead ocotillo enter the frame from the lower left corner and carry the eye toward the main subject, telling a story of life and death in the desert.

Gently curving wings of the grey gull serve as lines that lead the eye to the focal point of the composition, the gull's face. The image was cropped to allow the wing on the right to enter the frame from the corner.

Framing devices

Without question, the most useful edge merger is a framing device. Framing is a useful visual technique that focuses attention directly on the most important area of a composition. Positioning dark borders around the edges and corners of an image helps contain the viewer's eye and takes it on the express route to the main subject. The outlining dimensions of the frame can be rigidly straight or softly curving. The eye is easily led by the strength of contrasting tones and pleasing shapes.

Common framing devices include architectural structures such as doorways, windows, or archways; natural materials such as trees, branches, or rocky outcroppings; and sometimes even a well-placed shadow lending a framing effect to a scene. Most often, framing devices are silhouettes, following the theory that the eye quickly and easily skips past dark, shadowy parts of a composition and heads straight to the brightest areas. Framing devices normally have little detail or texture that might cause the eye to stop and investigate. Simplicity, smoothness, and darker tones work best for framing techniques.

Artfully incorporating a framing device in a photograph is more challenging than it looks. It's particularly effective when the result is subtle or clever. This visual technique lends a nice touch to a composition by adding interest, depth perception, and eye control. But it also can appear trite if not well suited to a photograph's subject matter, so it should be used sparingly and with good reason.

Framing can also appear heavy handed if the device overwhelms the subject. Ask yourself if the framing adds or detracts from your scene. Sometimes framing just adds distracting clutter, but at other times it makes the difference between an ordinary image and a stunning one. It is a technique befitting of the sage advice, "less is more." A frame can become overwrought if it tries to be too clever. But when skillfully integrated into a composition, the framing device does its job without much notice.

Important framing variables to consider are focus point and depth of field. Foreground framing devices can be some distance in front of the subject being framed. If maintaining sharp focus from the front to the back of the scene is desirable, lens focal length and aperture become vital factors in achieving a successful framing effect. Remember that shorter focal lengths and smaller apertures provide larger zones of sharp focus.

Selecting the right focal-length lens for framing techniques is important. Choose a medium telephoto lens and back the camera position away from the framing device, allowing the lens' magnification to compress the scene and optically bring the subject and frame closer together. To keep your subject in focus and the frame out of focus, make certain your autofocus (AF) sensor is locked onto your main subject and not on the framing device.

In some situations, keeping your main subject in sharp focus and allowing the framing device to go slightly out of focus is another good way to bring immediate attention to your focal point. The viewer's eye is attracted first to the brightest and sharpest area of a photograph, with the softened form of the frame serving as neutral territory. Utilizing a dark or silhouetted framing element such as a leafy tree branch that is just a bit blurry can enhance the effect.

Framing with a black silhouette adds a stronger sense of depth. To accomplish this effect, choose a longer focal length lens or a large aperture. Focus on your subject for sharpness, allowing the foreground branches to form soft, out-of-focus edges. But be judicious in your selection of framing devices, especially when using a silhouette technique and selective focus. You don't want your framing device to appear as just a black blob with no relationship to your subject.

Lastly, framing devices do not necessarily have to completely surround the edges of your image on all sides to qualify as a frame and contain the viewer's eye. Sometimes the framer only needs to cover one or two sides to be effective. For instance, an overhanging tree bough at the top of an image offsets the brightness of a plain blue sky, redirecting the eye to more important parts of your composition.

Framing is particularly effective when the result is subtle or clever.

Framing with a black silhouette adds a stronger sense of depth.

Overhanging tree boughs form a dark framing device that helps contain the viewer's eye and focus attention on the main subject, the church.

Horizontal and vertical lines

As we've seen, horizontal and vertical lines, which run at 90-degree angles to the lines of the viewfinder frame, reduce energy in a composition. To incorporate lines effectively in a composition, let the lines themselves dictate your camera orientation. Turn the camera's frame up into the vertical position to take advantage of strong vertical lines, and likewise, position the camera frame horizontally to make the most of long horizontal lines.

These long lines also can cut the frame into separate areas on opposite sides of the line, so be mindful of the consequences. Intentionally bisecting a scene this way effectively creates the possibility of two different scenes in one photograph and allows you to tell a story in an unconventional way. But placement of the dividing line must be precise to pull it off successfully. Skillfully done in the right circumstances, this technique is an appealing trick of the eye. It can captivate viewers with the juxtaposition of two conflicting stories in a single image.

Most often, it's best to break up long, placid horizontal and vertical lines with overlapping mergers to prevent their calming effects from dominating a composition. It's especially useful in landscape photography to interrupt a long horizon line with intermittent mergers, such as trees, buildings, or mountains, to minimize the horizon's length and disrupt its symmetry.

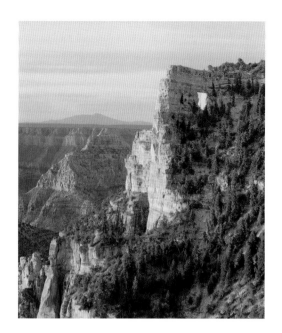

The merging lines of Angel's Window interrupt the distant horizon cutting through this composition to minimize the impact of the placid horizon line.

Long, placid horizontal and vertical lines can dominate a composition. Reduce their tranquil effects by placing overlapping mergers along the lines to break them into shorter, more manageable segments.

Dynamic diagonals

The most dynamic of all lines in composition are diagonals. Visual tension increases because diagonals look like lines knocked off balance. The desirable energy they create comes from their appearance as falling vertical lines or rising horizontal lines. This instability stimulates the eye and brain and boosts the inherent sense of motion in a photograph.

With all this energy going for them, diagonal lines make perfect design elements. But as with any line, they call for thoughtful incorporation in a composition. Careful placement of diagonals and awareness of their motion effects are key considerations. A strong diagonal leading line works against you

if it inadvertently escorts the eye right out of the photograph. You don't want to cause a premature exit for the viewer.

Whereas horizontals and verticals tend to divide and contain, diagonals connect. Because of the aggressive nature of diagonal lines, eye movement speeds up. Following the line, it reaches the focal point much faster. Strategic placement of important compositional elements at points along one or more of these oblique lines simplifies the eye's route and maximizes the viewer's experience.

Diagonal lines that reach into the corners of the frame can act as conduits to eye movement. Corners make a perfect entry point for the viewer's eye. Lines

Diagonal lines are introduced to the scene by tilting the camera's perspective, turning a static grid pattern of horizontals and verticals into angular leading lines.

leading into the frame from the upper left or lower left corners are logical places to begin the exploration of a photograph in the left-to-right directional flow of our Western world. But the corners also make the perfect exit point, sometimes allowing the viewer's eye to leave the image if the flow of lines leads out of the frame.

If your chosen camera position doesn't offer any diagonal lines to build into your composition, explore other perspectives that might create diagonals out of verticals or horizontals. The idea is to prevent the predominant lines from running parallel to

the top and bottom edges of the frame. Changing camera position or tilting your camera pivots the prevailing lines in a scene. The effect is even more pronounced when viewed through a wide-angle lens, which, as we know, distorts and exaggerates the convergence of lines.

The most dynamic of all lines in composition are diagonals.

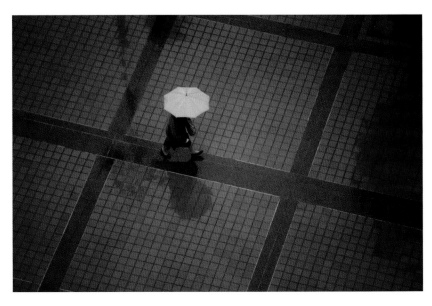

Leading lines

Fallen aspen trunks echo the trunks of the standing trees and serve as a pair of strong diagonals that deliver the eye quickly to the composition's focal point. Utilizing valuable corner space, the leading lines are introduced where the viewer can lock on and follow them to their destination. A wide-angle lens exaggerates perspective and accentuates the strength of the leading lines, providing a spacious feel to the pastoral scene.

Exiting lines

Strong diagonal lines add energy and motion but can also work against you if they lead the viewer's eye out of the photograph. At first glance, this scene seemed to come together in a useful assembly of leading lines. However, the most powerful line in the scene, the brightly lit diagonal in the foreground, leads the eye right out of the frame at the upper left corner. The flow of the lines doesn't succeed in delivering the eye to the focal point of the sunlit buttes in the upper right of the scene.

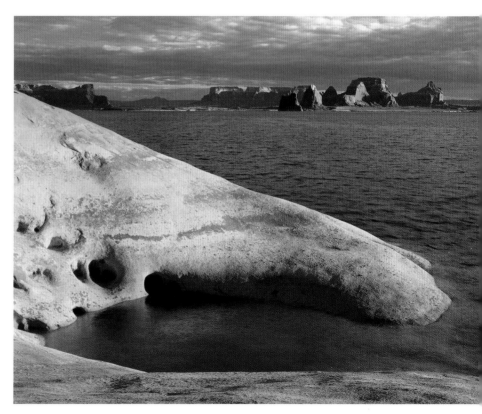

> Corners make perfect entry points for the viewer's eye. Lines leading into the frame from the corners are logical places to begin the exploration of a photograph. But corners also make perfect exit points, allowing the eye to leave the image if the flow of lines leads out of the frame.

S-curves and z-lines

When it comes to leading lines, there is none so graceful as the sweep of an S-curve. Roads, trails, and streams often provide the classically elegant shape that gently guides the eye to its appointed destination. Many of the sensual curves in nature add a gentle motion to a composition, lending a restful, passive mood to any photograph.

Effectively integrating a curving line into a photograph requires plenty of space for its full form to unfold. Let it meander back and forth, undulating through the scene. Cropping too tightly prevents the curve from developing. Be wary of a merger with the frame's edge that could interrupt the fluidity and grace of the line.

The zigzagging motion of a Z-line (or three merging lines that appear to form a Z) can accomplish a visual effect similar to the S-curve. Zigzags, because of their strong diagonal lines, bring dynamic energy to a photograph. Z-lines create faster eye movement than S-curves, but they also require a spacious composition with room for all three segments of the Z to spread out.

If possible, bring an S-curve or Z-line into your scene from a bottom corner of the frame. It's the perfect starting point for the viewer to enter the scene. Strategic placement of your main subject along the course of either of these leading lines provides a pleasing arrangement and a classic vibe to any composition.

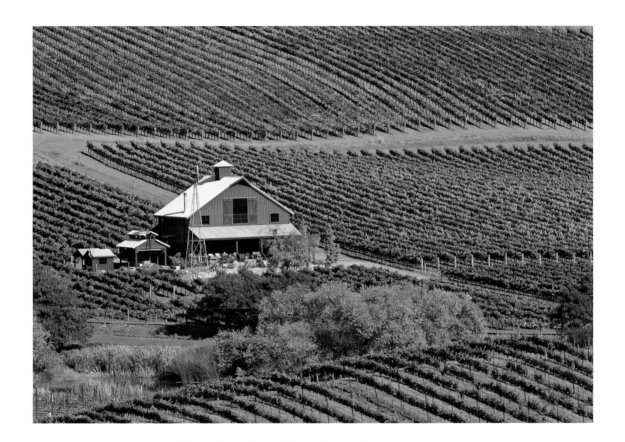

Z-lines

Camera position and perspective combined to present this fortuitous zigzag in the landscape. It's actually made up of three mergers on different planes compressed by a long focal length lens to appear as a backward Z. To set the composition's energy in motion, the zig-zag starts in the lower left corner of the frame and leads to a strong diagonal that delivers the eye to the focal point, a barn in primary red set against the complementary greens of the vineyard. The image is an extravaganza of lines, with the vineyard's row upon row of grapevines providing color and texture.

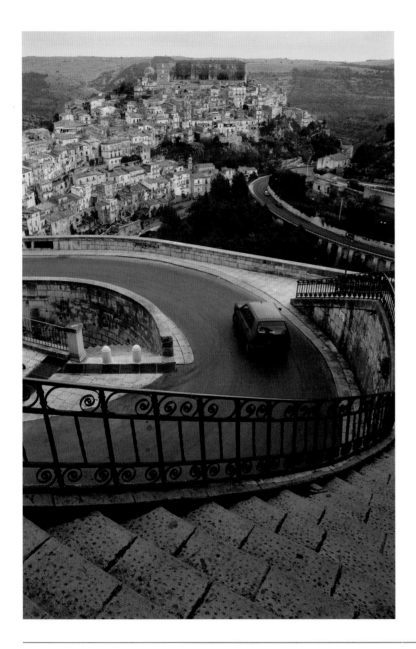

CURVES AND MERGERS GALORE

The sweep of curving lines creates a gentle flow in composition and a sensual route for the eye to follow. Here, the descending curve of the iron rail leads the eye down the staircase to the focal point of the red car positioned near the terminus of the line. The curve of the foreground street is repeated on the right side of the frame. The collection of curving lines in the scene tends to ease the tension created by an overabundance of mergers.

Assignment: Lines

Spend a day looking for lines in the world around you. Find examples of horizontals, verticals, diagonals, S-curves, and Z-lines, and try to build simple compositions featuring the lines in your photographs. If possible, make the line itself the main subject of the composition. Practice your line-recognition skills by mentally blocking out all other objects and focusing solely on the various lines in a given view. In the process, you'll learn to break down any scene to its basic line structure, and you'll come to understand the power of lines as an important design element.

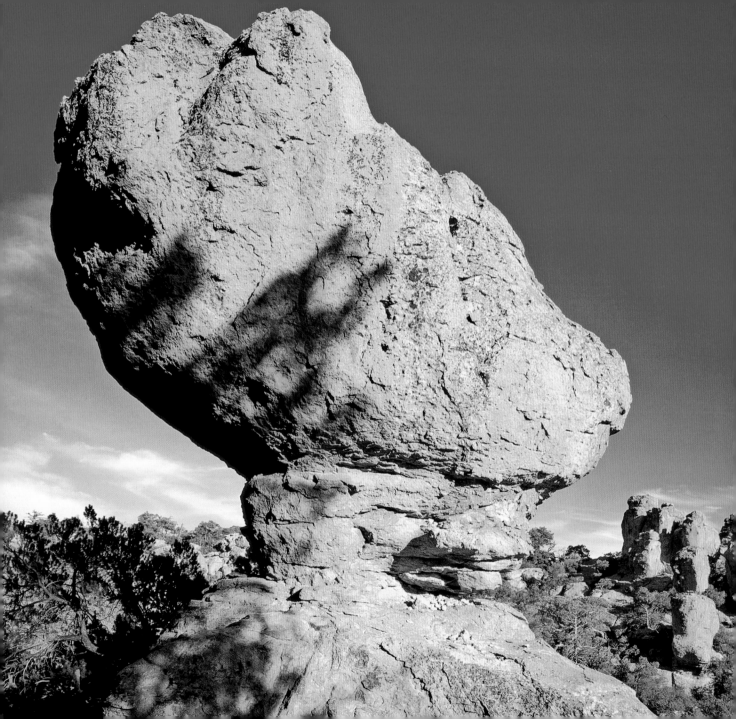

Chapter 6: Breaking the Rules

BY THIS POINT in the book, you've probably noticed the heavy use of words such as "usually," "normally," and "generally" in the discussion of composition guidelines. That's because there are no definitives in artistic expression. Absolutes exist only on the technical side. That's the dichotomy of photography.

Technical choices call for compromise in capturing proper sharpness and exposure. To reduce depth of field, adjustments must be made to aperture, focus, or lens focal length. To increase shutter speed, aperture or ISO must be altered. For each desired result, there is a required action. Get one of the actions wrong, and the resulting image suffers negative effects.

On the artistic side, however, the opposite is true. The words "always" and "never" have no standing in composition and design. The so-called rules of composition that we've explored suggest tried-and-true visual principles proven successful in most situations. But they're intended to inspire creativity and consideration for the possibilities, not as templates to be rigidly imposed.

Unlike photography's technical imperatives, the rules of composition cannot guarantee specific results. The variables of vision, imagination, whimsy, and other abstract notions go into the making of a successful photograph. And sometimes success is achieved by bending or outright breaking of the rules to good effect.

Shape, texture, and balance dominate this scene of geologic formations in Chiricahua National Monument. In a near/far composition, the foreground rock's size is exaggerated and juxtaposed against the repeating form of the distant rocks.

Breaking the rules doesn't mean throwing all convention out the window. Regardless of the degree to which the rules are manipulated, a successful photograph still should accomplish two things: engage the viewer and tell a story. Even in complete disregard for the rules, a photograph must exhibit strong compositional characteristics and convey its message clearly. When breaking with convention, do so knowingly and intentionally by identifying compelling reasons to employ unconventional techniques.

As we've seen, most of the rules are based on theories of asymmetry in off-center arrangements that promote the positive influences of increased energy and motion. Rules tend to harmonize with the brain's natural tendencies. Reasons for intentionally breaking a rule stem from the need to disrupt that harmony or disturb the expected order of things. When effectively executed, those disruptions generate drama, dynamic tension, and visual surprises. They turn a photograph's story toward the unexpected, which can be a treat for the eye.

First among the reasons for breaking with traditional rules is setting an energy level that befits the main subject and theme of your photograph. Every photographic situation doesn't demand a strong sense of motion or energy to successfully tell its story.

Second, rules should be manipulated to instill a mood suitable to the subject and narrative. Calm, pensive, or brooding are legitimate emotions to be conveyed in a photograph as well, calling for the right compositional dynamic to set a proper tone. Bending or breaking the rules may help establish a lower energy level more appropriate to a quiet scene. The degree to which you exploit the rules is determined by what you want to say about your subject.

Eschewing traditional techniques lets you explore nontraditional arrangements that can result in edgier photographs. Compelling compositions are just as possible by breaking the rules as they are by adhering to them. The art is in the execution.

It's necessary to gain some practical experience learning the rules before you can know when it's appropriate to deviate from them. You need to walk before you can run, as the old saying goes. The best of rules, when you know them, become simple, helpful guidelines built on common sense. They suggest ideas that achieve success with relative consistency.

As you get accustomed to incorporating the spirit of the rules into your compositions, interpreting every scene becomes much more intuitive. Conscious consideration of the rules no longer is necessary once you've developed a better understanding of what works and what doesn't. It's an exciting time in your artistic growth when your ratio of successful photographs sharply rises. When you reach that plateau in your progress, it can seem as if there aren't enough hours in the day for photography.

Up until now, we've addressed factors that go into the making of harmonious compositions. Of course, photography is capable of telling many kinds of stories, not all harmonious. Let's explore counterintuitive approaches that create dynamic tension.

There are no absolutes in artistic expression, but break the rules with good reason.

When breaking the rules, do so knowingly and intentionally.

Breaking the rules doesn't mean ignoring all convention. Regardless of the degree to which the rules are manipulated, a successful photograph still should accomplish two things: Engage the viewer and tell a story.

Apt situations for ignoring the rules:

- Setting appropriate mood and energy level
- Adding humor
- Photographing people and animals
- Photographing scenes with dominant symmetry

Breaking the rule of thirds

Because we know that strict application of the rule of thirds calls for asymmetrical balance and off-center placement of the main subject, ignoring the rule tends to emphasize symmetry and centering. Of course, we've all heard the cautionary advice, "Never place the subject in the exact center of a photograph." But we also know the word "never" doesn't apply to composition.

In most circumstances, centering the subject makes a photograph look unoriginal and devoid of imagination. But under certain conditions, the symmetry of a center-balanced design makes perfect sense. It costs you only a few extra minutes to experiment with a couple of different and unconventional options for a composition, even if only to satisfy your curiosity. Sometimes trying unusual arrangements leads to surprisingly good results. At other times, what happens in the viewfinder stays in the viewfinder. But it's okay to test the rules.

Situations appropriate to breaking the rule of thirds often involve clean, simple compositions with a singular subject and a plain or smooth background. With no other compositional elements to balance against the main subject, there's no justification for off-center arrangement. In such cases, placing the subject left or right of center only wastes space and opens up a large empty area on one side of the photograph in which the viewer's exploring eye will most likely get lost. It's usually a good idea to get close and fill the frame with your subject when using a centering technique.

Prominent patterns and textures also provide appropriate circumstances for compositional symmetry. Repeating lines and concentric shapes add rhythm and visual design to any scene.

When the pattern extends beyond the edges of the frame on all four sides, its visual strength is amplified, creating symmetrical conditions perfect for a centralized subject. Using your main subject as the lone anomaly to break up a pattern provides a point of contrast and a place of brief rest for the viewer's eye before it jumps back into the pattern again.

A center-weighted composition that successfully breaks the rule of thirds builds dynamic tension into a photograph by introducing a subtle, unsettling element of surprise. Remember, when our brains find symmetry in situations where it's not expected, we take pleasure in reconciling the irony of it.

Situations appropriate to breaking the rule of thirds often involve simple compositions with a singular subject, symmetrical arrangement of elements, or a plain background.

Repeating patterns, textures, and concentric shapes tend to emphasize center-weighted compositions.

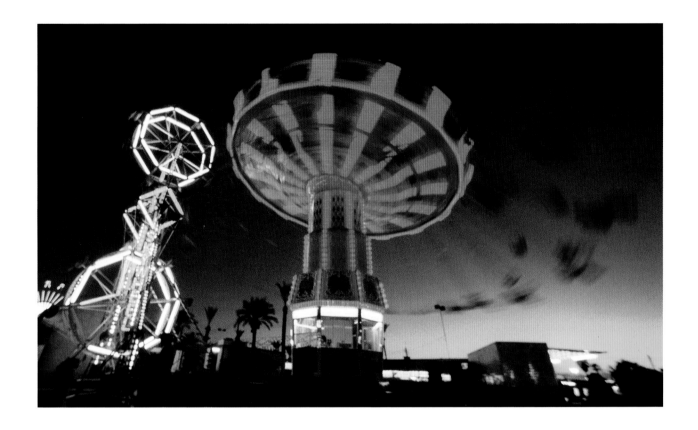

CENTERING THE SUBJECT

Bull's-eye compositions don't normally create pleasing designs for the viewer's eye to explore. With the main subject dead center, the eye is less likely to examine the entire image. The mind doesn't sense any instinctive direction in which to move. However, scenes with a strong, single subject and a simple background lend themselves to a centering technique. Designing a composition with only a couple of elements negates the need for off-center placement of the main subject—the simpler the elements, the stronger the design. It also helps to move in closer and fill the frame with the subject.

Breaking the rule of space

As discussed in Chapter 4, the rule of space calls for positioning the main subject opposite the largest portion of the frame. The idea behind the rule is to provide more space in front of your subject and less space behind it. This arrangement influences a composition's directional flow, leaving the subject room for its implied motion toward the larger portion of the frame. And it seeks to create harmonious spatial relationships among compositional elements and the edges of the frame.

Ignoring the rule reverses those spatial allowances in front and behind the subject. The arrangement of elements leaves less "active" space in the leading direction, emphasizing where the subject has been rather than where it's going. Diminished "nose room" builds spatial tension between the subject and the edge of the frame, an intriguing effect if there's something interesting for the eye to explore behind the subject.

Opening up more room behind the subject also allows you to bring additional context to the subject, so be sure the elements filling this area of your composition are compatible with the theme of your photograph. Discordant or conflicting objects occupying this space may inject more intrigue and drama into the story of your photograph, but they also may have the potential to muddle the message if the juxtaposition confuses the viewer. Beware of each object's influence on the overall story you're attempting to tell.

Ignoring the rule of space creates spatial allowances behind the subject. Placement of elements allowing a small amount of "active" space in the subject's leading direction emphasizes where the subject has been rather than where it's going.

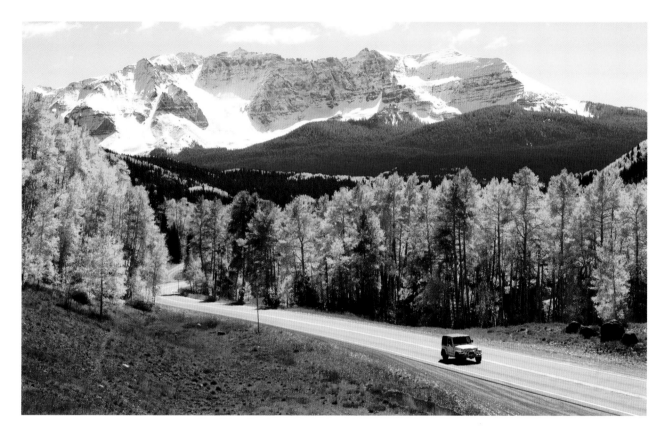

Without the Jeep, the road entering the frame at the lower right corner would generate a strong right-to-left flow in the composition, leading the eye into the scene toward the majestic mountains. However, the Jeep's placement completely reverses the energy and flow by allowing a small amount of active space in the Jeep's leading direction and creating large spatial allowances behind it.

The rule of space calls for positioning the subject in a composition to leave room for its implied motion into the larger portion of the frame.

Tension is created between the subject and the edge of the frame with little space for its implied motion. This composition emphasizes where the boat has been rather than where it's going.

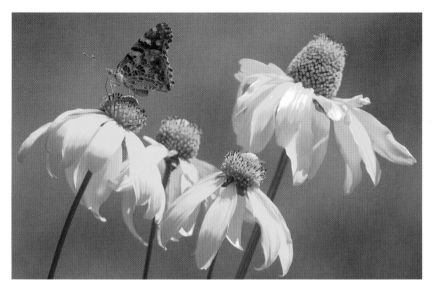

The butterfly's leading direction toward the smaller portion of the frame creates positive tension in the composition.

Portraits

A corollary to breaking the rule of space has similar effects on portraits of people and animals. Composition techniques that create spatial tension between the subject and the frame's edges can influence the perception and mood portrayed in the portrait.

The classic formal portrait is customarily composed with eyes looking at the camera and ample space around the subject. This style often employs the rule of thirds, aligning the subject's eyes with the upper horizontal grid line to create a nice, well-balanced photograph. A traditional portrait generally does a good job of showing what the subject looks like—nice smile, look at the camera, say "cheese"—but tells us very little else about the person. Look at the portraits in your high school yearbook. Boring!

Breaking the standard portrait rules can produce a much more insightful and interesting portrait that creates a mood and reveals more about the subject's personality and character. Start by moving in closer or zooming in on your subject, focusing on just the important facial features—eyes, nose, mouth, chin, ears, and hair. Remembering gestalt theory, allow the subject's head to bleed out of the viewfinder frame around the edges. Leaving only a small amount of "nose room" in front creates dynamic tension.

Tweak perspective and camera position until only the essence of the subject's face is exposed to the camera. Experiment with the subject's gaze, alternately looking directly at and away from the camera, to capture a variety of looks and facial expressions. Maintaining sharp focus on the subject's eyes is vitally important in portraiture. If shallow depth

of field becomes a problem, consider switching to a shorter focal length lens or try a smaller aperture to ensure that all facial features are tack sharp.

Make certain that your subject's eyes have that little sparkle known as "catch light" reflected in them. This tiny specular highlight draws attention to the subject's eyes and conveys a sign of life, a vital element in any portrait. A subject can appear lifeless or evil without catch light in the eyes.

This portrait technique for people and pets breaks with the dull and demure style of traditional portraiture and emphasizes your subjects' best qualities.

Breaking the rule of odds

The rule of odds relies on the geometry of implied lines by drawing connections between odd numbers of objects in a composition. Geometric design is especially strong where objects occur in threes. The unseen lines that link three elements together create asymmetry in a classic triangular shape. The principle behind the rule of odds finds triangles more aesthetically pleasing to the eye than the square shape suggested by four objects. Odd numbers are more interesting and compelling because of the unresolved discord they

create. Desirable conflict and dynamic tension are inherent in odd numbers.

On the other hand, even numbers of objects resolve conflict, reducing energy and calming eye movement. The resulting geometric symmetry casts a feeling of serenity over the scene and displays the softer side of composition. In certain circumstances, the placid portrayal of a subject can be beneficial when a passive mood is suitable to the story being told in a photograph.

Sometimes the symmetry in a scene is impossible to overcome, but dealing with even numbers of objects is not the kiss of death to a composition. In situations where you have no control over the presentation of elements, breaking the rule of odds may be mandated by the circumstances. When space restrictions don't permit you to compose elements the way you want them, it's okay to go with the flow by working with whatever the scene offers. Forcibly imposing any rule on a scene can be difficult to pull off successfully if the elements of design conspire against it, but be aware of the effects of odds and evens.

Breaking the standard portrait rules can produce a more insightful and interesting portrait that creates a mood and reveals more about the subject's character.

Odds versus Evens

The rule of odds bases its theory on desirable unresolved conflict and dynamic tension that the brain perceives in odd numbers of objects. Triangular asymmetry created in threes is especially pleasing to the eye. The geometry in even numbers of objects, particularly in groupings of four, resolves conflict. The symmetry of fours reduces eye movement, energy, and motion, thereby displaying the softer side of design. Geometric symmetry is not inherently bad for composition, but it conveys a mood of calm and serenity in a photograph.

Breaking horizon rules

One of the most basic rules governing horizon placement warns against bisecting a scene with the horizon line. To prevent the horizon from running straight through the middle of compositions, the rule calls for raising or lowering the horizon line in the frame to run along the rule-of-thirds lines. Placing the horizon higher in the composition gives proportional emphasis to interesting foregrounds, whereas lowering it takes fuller advantage of dramatic skies.

Yet there may be situations when splitting a scene through the center with the horizon line makes perfect sense. Situations appropriate to center placement usually involve symmetrical arrangements, such as the reflection of a landscape mirrored on the surface of a lake. In these circumstances, bisecting the frame with the horizon line amplifies the scene's symmetry and plays up the repeating lines, colors, and shapes in the upper and lower halves of the composition.

Another simple but important rule of landscape photography calls for keeping horizons straight and level. In fact, outdoor photography of all types usually benefits from horizon lines being perfectly parallel to the top and bottom edges of the viewfinder frame. "Level horizon" should be on every photographer's mental checklist before pressing the shutter-release button.

If precision alignment isn't your strong suit, use a small bubble leveler that attaches to the camera's hot shoe, or utilize the grid lines in your viewfinder's focusing screen to aid you in keeping horizon lines straight.

In most instances, you want to follow horizon rules faithfully. However, there are times when intentionally tilting the horizon line adds energy, motion, and fun to an image. Break the rule by boldly tipping the camera at an angle to pivot the horizon line. The key is to make the effect look obvious and intentional. This is no time to be timid. If the horizon's angle is only slightly tilted, it may look like an accident.

A 45-degree angle of tilt is not too much.

As we've seen, diagonal lines create their own energy in a composition. Rotating the camera tilts the placid line of the horizon and turns it into a motion-generating diagonal. And this technique is not just useful for horizon lines. Other lines in a scene also will be affected by off-axis tilt, creating more diagonals and additional energy. The effect works for floors, tabletops, and sidewalks too.

The technique is especially effective with still-life subjects and people portraits, adding plenty of whimsy and gravity-defying amusement to a scene. And it works to good effect by changing the viewer's perception of your subject even in situations where the horizon is not visible in the scene.

Tilting the horizon is an affectation that, if overused, can become trite, so discretion is advised in the use of this technique. But under the right circumstances, it can inject humor and quirk to an otherwise staid situation.

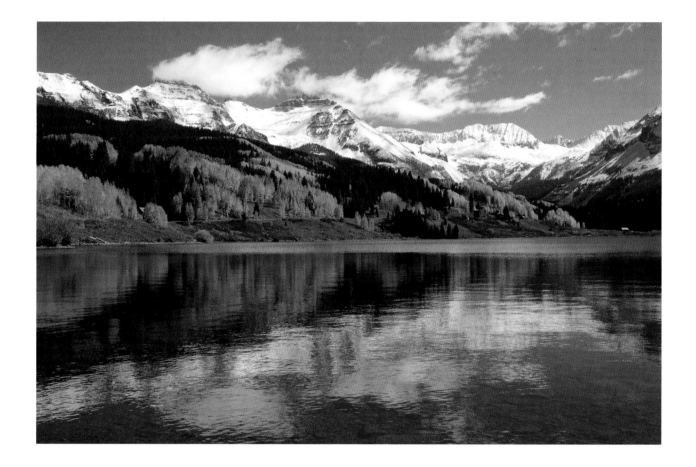

Bisecting a Scene with the Horizon Line

Ordinarily, it's best to follow rule-of-thirds guidelines by placing the horizon line off center in a composition to prevent bisecting the scene. This arrangement forces the photographer to feature the foreground or background based on the elements available. At other times, symmetrical conditions make center placement of the horizon the logical choice. In these circumstances, bisecting the frame with the horizon line plays up the scene's symmetry and repetition of lines, colors, and shapes in the upper and lower halves of the image.

Tilting the horizon adds humor and whimsy to otherwise staid situations.

Tilting Horizons

In most instances, it's important to make sure the horizon is perfectly level. However, there are times when intentionally tilting the horizon adds motion and fun to an image. Break the rule by boldly tipping the camera at an angle to pivot the horizon line. The key is to make the tilt look obvious and intentional—not an accident. Don't be shy. A 45-degree angle of tilt is not too much. Rotating the camera skews the placid horizon line and turns it into a diagonal full of energy.

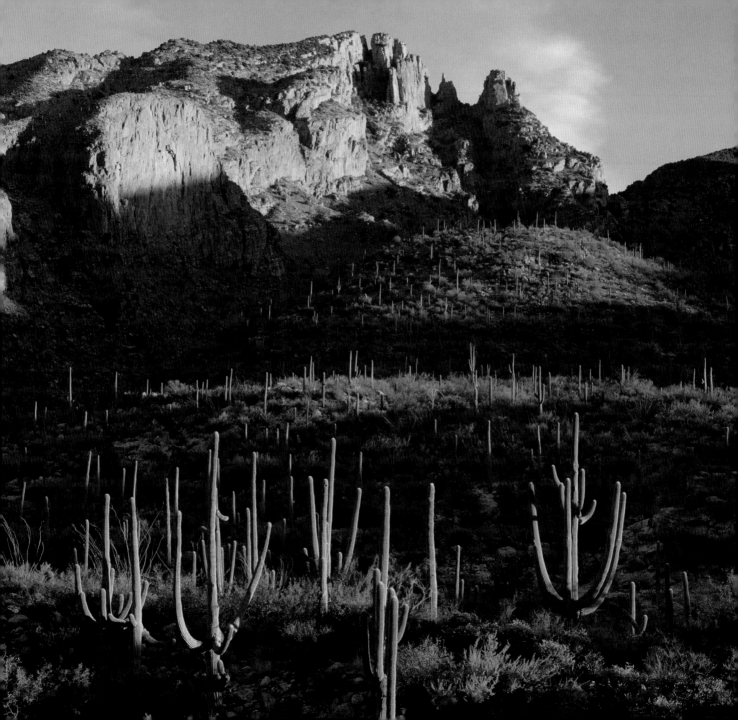

Epilogue: Where Do You Go from Here?

THE OVERARCHING goal of this book is to inspire the readers to explore and develop their artistic talents. Providing you with the proper compositional tools puts you on the path to creative self-expression where you can enjoy fuller photographic experiences. Your next step is getting out into the field where you can put your new knowledge to work. Once you get the hang of newfound techniques and skills, your imagination is the only factor determining how far you take it from here.

Though the old expression may be a cliché, experience really is the best teacher. Learning basic principles of composition gives you solid building blocks for designing successful photographs. We've addressed a number of hypothetical situations in the discussion of ways to organize pleasing compositions. But when it comes right down to it, practicing the craft of photography is the only way to improve your technique. No matter what your goals are in photography, the more photographic experiences you have, the faster your images improve. Each new situation broadens your perspective and prepares you for your next encounter.

Knowing that sunrise provides the best light and shadows on this scene of Finger Rock helped the photographer succeed in capturing the image at its best.

Practice is the only way to improve technique. No matter what your goals are in photography, the more experiences you have, the faster your images improve.

Have a game plan

Going into the field with a good game plan gives you decided advantages in bringing home better photographs. Timing is everything. The best season and the best time of day put you in the right place at the right time, so plan to be in locations when conditions are at their peak.

Photography is important enough to plan outings just for the purpose of photography.

Make it a priority by allowing plenty of time exclusively for photography in your vacation travel itineraries, and try to schedule your trip's activities with photography in mind. Be an opportunist, putting yourself in subject-rich environments early and late in the day when light is prime and conditions are maximized for good image making.

Stay alert to the sudden rise of the serendipitous. Often, an unexpected photo opportunity presents itself on the way to a planned photo shoot, so be receptive of the stimuli around you at all times. Have your camera and tripod at the ready to capture a fleeting moment at its climax. Photographer Jay Maisel, recipient of several lifetime achievement awards, says, "If you are out there shooting, things will happen for you. If you're not out there, you'll only hear about it."

Allow time exclusively for photography in vacation travel itineraries, and try to schedule your trip's activities with photography in mind. Be opportunistic by putting yourself in subject-rich environments early and late in the day when light is prime and conditions are best for photography.

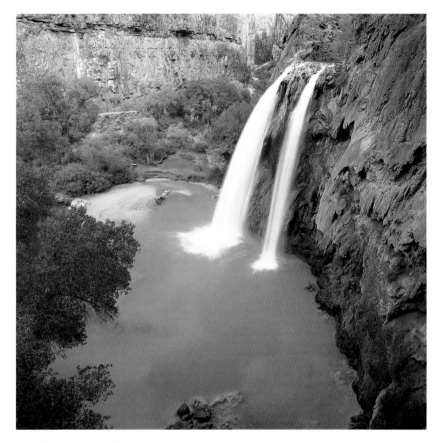

Havasu Falls in the Grand Canyon can be difficult to photograph in direct sunlight. Waiting for the soft light that occurs after the sun has dipped below the canyon's rim provided the perfect conditions.

Have your camera and tripod at the ready to capture a fleeting moment at its climax.

The order of events

In the scope of this book's instruction, steps to good composition are presented in a progressive fashion. In a nutshell, the procedure goes something like this: You see an appealing subject, you make sense of the subject by providing it context, and you capture the scene in a pleasing arrangement of elements.

In practice, however, these steps seldom follow such an orderly tack. Choosing a subject, finding a viewpoint, selecting a lens, and deciding on a perspective are not necessarily carried out in a linear

progression. The actual process is much more fluid and organic. That's the nature of artistic expression.

It's difficult to give priority to any individual step in the process. Interdependent relationships between subject, light, focal length, aperture, and shutter speed help determine the actual sequence. Often, the span of time to execute these steps is only a few seconds, especially when you're reacting quickly to changing light or dramatic events unfolding in front of you. Sometimes there's no time for contemplation. Capturing the moment quickly and efficiently becomes the immediate objective.

Hall of Fame basketball coach John Wooden had a maxim he applied to basketball, but it certainly is relevant in photography as well. During the pressure-packed moments of a game, when time was of the essence, Wooden instructed his players to "be quick, but don't hurry." That is, put yourself in position to succeed as quickly as possible, and summon all your resources and know-how in a focused and efficient manner. In these moments, the order of steps will follow its own natural course.

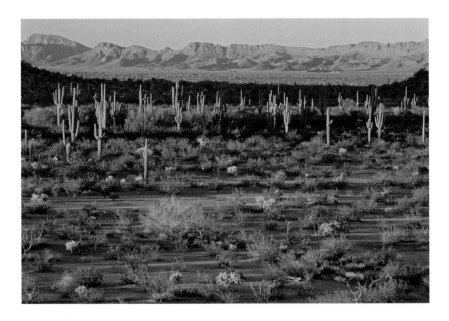

Light is at its peak for this scene at sunset. The juxtaposition of highlights and shadows adds loads of texture. At other times of the day, the light is unflattering for the scene.

> *The steps of composition seldom follow an orderly tack. Choosing a subject, finding a viewpoint, selecting a lens, and deciding on a perspective are not necessarily carried out in a linear progression. The actual process is much more fluid and organic. That's the nature of artistic expression.*

Work it

Once you're on location, allow yourself plenty of time to work each scene. No matter what a photographer's level of experience, from raw beginner to seasoned pro, being fully engaged in every photographic situation is the only way to arrive at the best compositional arrangement. Work each scene from different angles until you've exhausted all the options, keeping your eyes and your mind open to the visual possibilities. There's an attitude expressed by an ancient Zen proverb that sets the perfect frame of mind to take with you into the field: "Move, and the way will open."

When working in new or unfamiliar situations, be willing to make exposures without expectations. Don't be afraid of overshooting. Move closer to the subject and back away; tilt the camera; shoot both horizontal and vertical orientations; try wide-angle, intermediate, and telephoto focal lengths. For many photographers, it's a natural sequence on location to shoot, review, and refine. After each series of exposures, check your results to see if any of the images suggest a trend, and then explore in that direction.

Some images are intended simply as practical experiments or snippets for learning. Snap the shutter even if only to record some nuance about light, shadow, or color. Sometime down the road, the information garnered from these exercises will help you get the most out of situations when confronted with similar conditions.

Almost every subject offers at least one good viewpoint that shows off its best qualities, but every exposure will not necessarily be a masterpiece. Mistakes are a necessary part of the process, and photographers at every level must continually endure them. Improvements are born of those mistakes.

Try capturing a sequence of perspectives as you work each situation. Compare the differences and critique your results when you get back to your computer. This shortens your learning curve by visually demonstrating which techniques work and which do not.

> Move, and the way will open.
> —Zen proverb

Working the subject

When a subject is good and conditions are prime, make the most of the opportunity by working the scene from as many different angles as possible to ensure getting the most out of the situation. Circumnavigate the subject, changing foregrounds, camera angles, and lighting direction to capture a variety of views that tell a fuller story. Don't be concerned about the number of exposures being captured. There will be plenty of time later for culling the best images in the editing process on the computer.

Critique your results

Being honestly self-critical in evaluating your photography will serve you well on the way to improving your technique. Unfortunately, most of us are not the best evaluators of our own work. It's difficult for us to separate our images' artistic merits from the physical effort and emotion invested in capturing them.

Seeking the candid opinions of others gives you a completely different perspective and helps you see things you might otherwise miss. In the beginning, honest criticism of your art might be hard for your ego to bear, but forthright opinions can be very constructive if you're willing to listen. The intent of critique is to help improve your photography, so don't take it personally.

Consider enrolling in a photography workshop where you'll receive one-on-one instruction and feedback on your images from a professional photographer. Take advantage of direct access to the instructor's knowledge and expertise. Get answers to your questions and concerns. Workshops also provide opportunities to exchange ideas about techniques and share information about equipment with fellow workshop students. You'll find that you're not alone in your experiences.

Learning the art of photography is absorbed more through osmosis than the deliberate study of explicit directives. Acquiring knowledge and ideas comes by way of continued exposure until it becomes almost unconscious in nature. The process of trial and error provides the most direct route in developing the skills necessary to produce pleasing images on a consistent basis.

Countless times, photographers capture what they think is the perfect photograph of a scene, only to be disappointed with the final results when they get home and view it on the computer. And just as often, they're surprised to find that an exposure they didn't have high hopes for in the viewfinder turns out to be the best image.

The moral: Don't be hasty in making judgments about your compositions in the heat of the moment. You should be in acquisition mode while working in the field. Wait to evaluate your images after you've downloaded the files to the computer and you have more time to turn a critical eye on them. The mindset of the photographer differs completely from the mindset of the editor.

Being honestly self-critical in evaluating your images will speed your improvement. Seek the truthful opinions of others. Different perspectives help you see things you might otherwise miss.

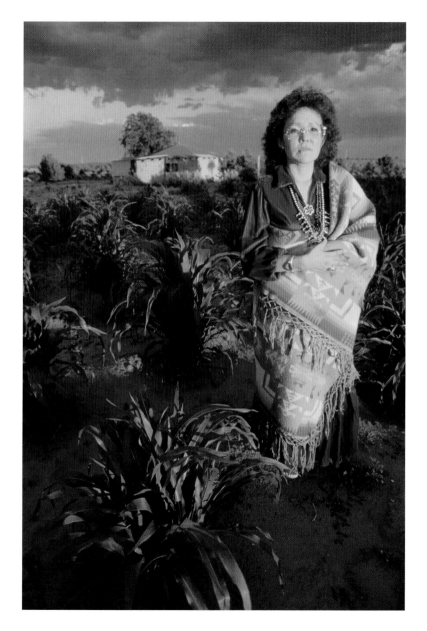

Working in the warm, soft light that occurs around sunrise and sunset puts you in position to capture scenes at their best. The quality of the prevailing light elevates this portrait of a Navajo woman standing in her cornfield.

Equipment and technology

Don't get too hung up on owning the latest camera gear. Many photographers believe that a feature-laden camera makes their images better. Not so. When admiring a beautiful painting, we don't credit the canvas and brushes used in creating it. Creativity is the product of the artist's vision, skill, and technique. Artistic ability rests within the person handling the camera equipment, not in the equipment itself. Even cell-phone cameras are capable of capturing interesting images if the photographer employs sound composition techniques.

It's true that digital sensors are continually improving, and image quality gets better with each new generation of camera. But technology is a means to an end. Don't move up to a more sophisticated camera until you're ready to utilize all of its new features.

Ultimately, technological advancements are simply newer tools to help you achieve your vision. Mastering the equipment's capabilities may make it easier to capture an image, but it won't make the image any better. Better images come from the mind and eye of the photographer.

Many photographers believe that a feature-laden camera makes their images better. Not so.

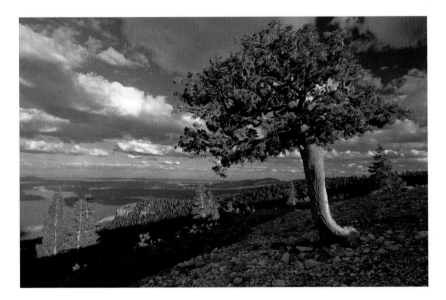

Photography teaches us to see the world differently. Even inanimate objects such as trees take on character and personality.

Trust that little voice in your head

Besides sheer enjoyment and creativity, the positive side effects of learning photography are compelling. Photography brings your inquisitive nature to the surface, pushes you to explore the world around you, and forces you to get involved with your subjects. Knowledge expands with each new encounter. Self-confidence grows with every step of the learning process.

The most persuasive aspect of photography lies in the power it holds to change people's perceptions. The unerring eye of the lens takes you beyond the obvious. Fixing the camera's incisive gaze on new subjects puts you inside the buffer zone of casual observation, revealing intricate details that would otherwise go unnoticed.

Photography is mind expanding in the way it develops heightened awareness. You learn simply by seeing. Dorothea Lange, the finest documentary photographer of the Great Depression, summed it up best when she wrote, "The camera is an instrument that teaches people how to see without a camera."

As with any art form, experimentation is an important key in developing your skills. Composing a photograph becomes much more spontaneous and intuitive when relying on your artistic instincts to figure out what works best in each situation. Trying a different approach or a new technique leads to discovery. Innovative photographer Duane Michals said, "Trust that little voice in your head that says 'Wouldn't it be interesting if…' And then do it."

As your skills and techniques improve, challenge yourself to learn more about the nuances of photography. You'll gain a deeper perspective on the medium by learning about photography's rich history. Pioneers such as William Henry Jackson, Dorothea Lange, Carleton Watkins, Margaret Bourke-White, Mathew Brady, and Edward Sheriff Curtis made significant contributions to photography long before it was considered an art form.

Many of the early masters expressed themselves with equal eloquence both visually and verbally. Books, essays, and interviews provide great insights on photographic styles, philosophies, and experiences, and thousands of websites present thought-provoking perspectives on an abundance of topics for those wanting to further their photographic education. Researching the lives and times of the influential photographers quoted throughout this book will give you a broader understanding of this diverse medium.

The world of photography offers a rewarding pastime that can be a constant companion for the rest of your life. With so many subjects to explore and innovative techniques and styles to challenge you, photography provides a creative vehicle for your imagination. Enjoy the ride.

And be sure to take this book along with you as a reference guide and refresher course at your fingertips.

Photography brings your inquisitive nature to the surface, pushes you to explore the world around you, and forces you to get involved with your subjects. Knowledge expands with each new encounter. Self-confidence grows with every step of the learning process.

As with any art form, experimentation is an important key in developing your skills.

Books, essays, and interviews provide great insights on photographic styles, philosophies, and experiences, and thousands of websites present thought-provoking perspectives on an abundance of topics for those wanting to further their photographic education.

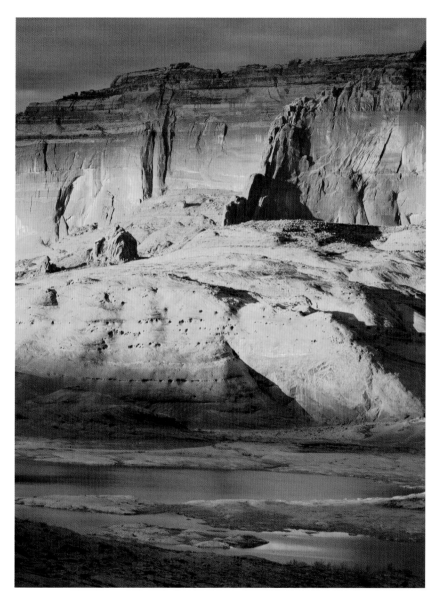

Constantly changing nuances of light and shadow provide the acts in an endless play of shape, form, line, and texture. Witnessing those fleeting moments is a reward in itself. Artfully capturing them in photographs allows us to share those treasured moments with others.

Websites worth exploring

- www.photography.com
- www.lensculture.com
- www.photonewstoday.com
- www.photographycorner.com
- www.photocritic.org
- www.picturecorrect.com
- www.photo.net
- www.photonhead.com
- www.resize.it
- www.photojojo.com
- www.theonlinephotographer.typepad.com
- www.naturephotographer.com
- www.photography.nationalgeographic.com/photography
- www.digital-cameras-help.com
- www.luminous-landscape.com
- www.kenrockwell.com
- www.geofflawrence.com
- www.masters-of-photography.com
- www.photoinsider.com/index.html
- www.artcyclopedia.com
- www.carletonwatkins.org
- www.garyladd.com
- www.joelmeyerowitz.com
- www.henricartierbresson.org
- www.anseladams.com
- www.edward-weston.com
- www.jaymaisel.com
- www.peteturner.com

Suggested reading

- *The Focal Encyclopedia of Photography,* Fourth Edition, by Michael R. Peres, Focal Press
- *The Focal Digital Imaging A-Z* by Adrian Davies, Focal Press
- *Criticizing Photographs: An Introduction to Understanding Images,* Third Edition, by Terry Barrett, McGraw-Hill
- *Light and Lens: Photography in the Digital Age* by Robert Hirsch, Focal Press
- *Understanding Digital Cameras: Getting the Best Image from Capture to Output* by Jon Tarrant, Focal Press
- *Digital Landscape Photography: In the Footsteps of Ansel Adams and the Masters* by Michael Frye, Focal Press
- *Through the Lens: National Geographic Greatest Photographs* edited by Leah Bendavid-Val, National Geographic

- *Michael Freeman's Perfect Exposure: The Professional's Guide to Capturing Perfect Digital Photographs* by Michael Freeman, Focal Press
- *Examples: The Making of 40 Photographs* by Ansel Adams, Adams Publishing Trust
- *Grand Canyon: Views beyond the Beauty* by Gary Ladd, Grand Canyon Association
- *Langford's Advanced Photography,* Seventh Edition, by Efthimia Bilissi and Michael Langford, Focal Press
- *The Elements of Photography: Understanding and Creating Sophisticated Images* by Angela Faris-Belt, Focal Press
- *Nature Photography: Insider Secrets from the World's Top Photography Professionals* by Christopher Weston, Focal Press

Index